DRAW YOUR DAY

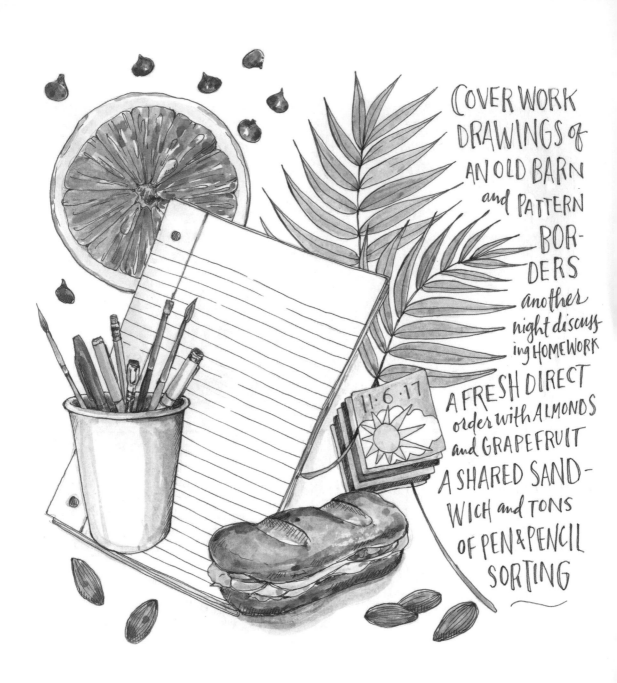

COVER WORK DRAWINGS of AN OLD BARN and PATTERN BOR-DERS another night discussing HOMEWORK A FRESH DIRECT order with ALMONDS and GRAPEFRUIT A SHARED SAND-WICH and TONS OF PEN & PENCIL SORTING

11·6·17

DRAW YOUR DAY

An inspiring guide to keeping a sketch journal

Samantha Dion Baker

WATSON·GUPTILL

CALIFORNIA | NEW YORK

CONTENTS

Introduction 1

GETTING STARTED

BENEFITS OF A DRAWING PRACTICE 11

CREATE A DRAWING PRACTICE 19

CELEBRATE MISTAKES 27

TOOLS AND MATERIALS 33

INSPIRATION 59

NOW IT'S TIME TO DRAW 73

IDEAS FOR DRAWING

Typography and Signage 90

Weather 94

Nature 98

Buildings and Architecture 102

A Busy Day 106

Quotes and Special Words 110

Everyday Objects 114

Food and Drinks 118

Animals 122

People 126

Conclusion 130

Resources 132

Acknowledgments 134

About the Author 136

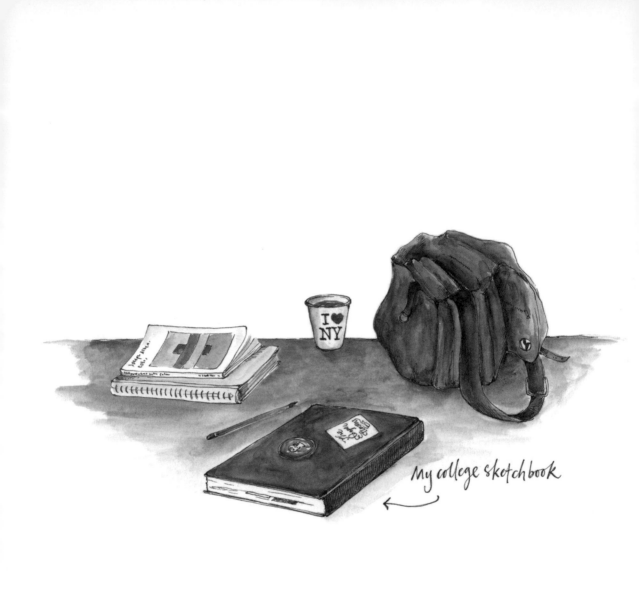

My college sketchbook

INTRODUCTION

It's hard to say when I first began keeping a journal, but it was probably in high school. I remember spending nights avoiding my homework, writing and doodling in my diary. I never wanted to reveal too much for fear someone would read it, so I always held back a little bit and expressed serious thoughts and feelings through random doodles and drawings, only hinting at the big stuff with a few words. Drawing made me feel less vulnerable than writing out all of the details of my days, and creating those drawings helped me decompress. Handwriting as an art form is an expression of oneself, and I have a deep appreciation for how different writing utensils can alter my script. I have always loved the act of simply writing words—stringing them together in various shapes and sizes or using them to create abstract patterns. The words don't actually need to say anything. Writing words or single letterforms in

groupings—more like stream of consciousness thoughts—has always been a fluid and calming exercise for me. In college I had sketchbooks filled with random writings of patterned words alongside small drawings. I would photocopy these to use in collage work. The sketchbook I used for class notes and planning how I would solve design projects was the most precious thing in my schoolbag. My husband even proposed to me in one of my journals. When I became a mother, I filled journals with our boys' first words and milestones. I keep travel journals on every trip we take, and I encourage my kids to always have a blank book in their bags as well. There is something about turning the pages of a book—this compact object that contains days, or months, worth of artwork and thoughts, transporting us to another place and time—that has always been so satisfying to me.

As the years passed, I noticed that the drawings were disappearing from the pages of my journals. As my life got busier with work and family, I spent less and less time drawing. Months turned into years, and eventually I felt as if I could no longer draw. I had spent more than eighteen years working as a graphic designer, and one day I realized that I was desperate for a creative outlet free from computer screens and technology. When I had our boys, I was running a successful design business, and I continued to work throughout their young years. I somehow balanced work and being Mom, but by the time they were in school full time, I knew the commercial design work wasn't scratching my creative itch. The thought of sitting at the

computer for eight hours a day became daunting. So I began to look for a new creative hobby that could enhance my days. But where to begin and what to do? These were scary questions, and I felt that the best place to start was in one of my trusted journals. My husband encouraged me by saying, "You used to draw more. The talent is there, you just have to find it again."

So I made a commitment to include some drawing practice on each page of my journal. I had no idea what would happen, but I began to practice. I figured there was no safer place than inside my own private journal to relearn how to draw by hand. After a few months of drawing patterns, letterforms, birds, and food, I gained confidence. At that point I decided not to just draw random sketches, but to use the pages to draw a true record of my life. I thought, *Instead of writing out my day for my journaling practice, why not illustrate it?*

As this practice and transition was happening in my journal, I began to share the process on Instagram. I told only close family and friends about it at first, but as my journal pages evolved, my posts developed a following. I was amazed by the feedback and encouragement I received from others. It was transformational. Recording my days and sharing them forced me to slow down, to appreciate all of the big and little things that happened each day, to take risks, and to really think about my process.

A bunch of Lavender

A feather

In the beginning, my journal pages were filled with doodles and patterns alongside my writing—a single doorknob, an eye-catching sign, some lettering, a cat that crossed my path—and progressed to illustrating the breakfast I eat with my boys, a book we read together, a storefront that catches my eye on the walk home, and the weather. (In fact, the weather is almost always recorded on my pages. If it's a rainy, gloomy day, and all I do is stay home in pajamas and watch movies with my kids, then that's what I illustrate.) Some days I fill two or three pages with the details from just one day.

In 2015, I illustrated a page I called "An Epic Whole Foods Shop" of the food items in my grocery bag. I was surprised to see how much this page resonated with so many of my followers on social media. I realized how positively people respond to sketches of the everyday, the mundane, the ordinary. We all buy eggs and black beans, but in illustrating them we truly see them, and they suddenly become special and beautiful.

The act of writing and drawing, side-by-side, on a single entry forced me to question whether my journal had become a sketchbook, or my sketchbook had become a journal. Realizing that the pages were a happy marriage of both words and pictures, I found a word to describe my books. I certainly was not the first to use the term "sketch journal," but it has now become a trademark to the style in which I create my pages. As my sketch journaling became a regular practice, so did the act of photographing and sharing my progress. Posting the pages each day and waiting to see which ones my followers responded to became part of my routine. The feedback has helped me develop the craft and style of my drawings and to see my work from different perspectives. I have been astonished by how many people want to begin a similar daily practice and keep a sketch journal like mine.

I am grateful to inspire others to stop and take time for themselves, to turn away from technology for a little bit, to experiment, and to express themselves creatively each day. Watching others create their magical journals filled with artwork and memories and answering their questions brings me joy. In fact, I enjoy it so much I decided to make this book to share my process and ideas with everyone. In the pages ahead, you will find tips for starting your own similar practice, materials I suggest, some drawing exercises for you to try, ways to celebrate mistakes while coping with the learning curve, and prompts for spotting the universal in the everyday and capturing it through color, collage, and illustration.

This book is meant to be an inspiring and helpful guide to sketch journaling, but by no means is this an exact recipe. Feel free to reference bits and pieces, or follow along chapter by chapter. My hope is that you will not only develop and enjoy a daily drawing practice, but that you will gain an inspired awareness of the beauty around you, to help you see that no matter how mundane a day may seem, there is always a way to make your experiences come to life through your words and drawings.

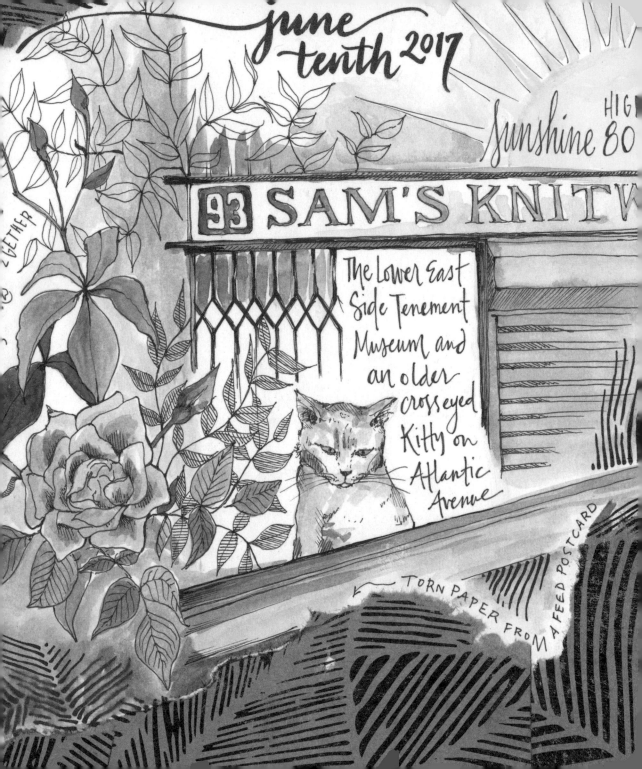

june
tenth 2017

sunshine HIGH 80

93 SAM'S KNITW

The Lower East
Side Tenement
Museum and
an older
cross eyed
Kitty on
Atlantic
Avenue

TORN PAPER FROM A FEED POSTCARD

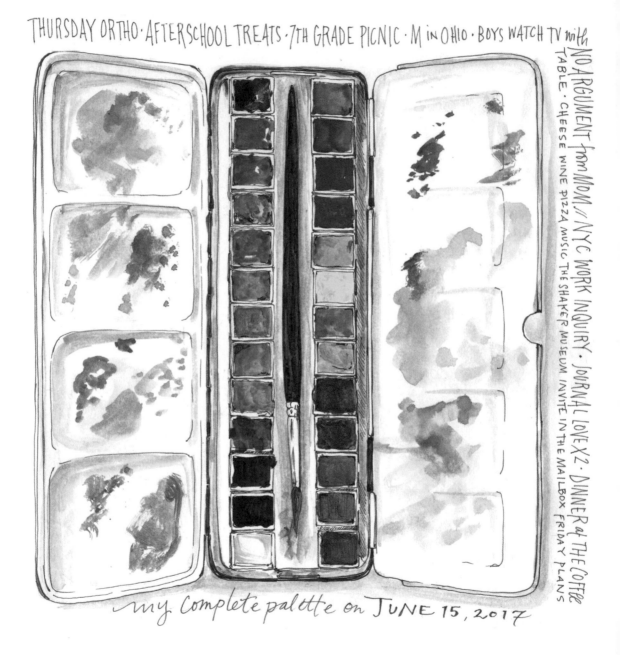

THURSDAY ORTHO · AFTERSCHOOL TREATS · 7TH GRADE PICNIC · M IN OHIO · BOYS WATCH TV with NO ARGUMENT from MOM // NYC WORK INQUIRY · JOURNAL LOVE X 2 · DINNER at THE COFFEE TABLE · CHEESE WINE PIZZA MUSIC THE SHAKER MUSEUM INVITE IN THE MAILBOX FRIDAY PLANS

my complete palette on JUNE 15, 2017

GETTING STARTED

July 2, 2017

HYDRANGEA & FIREWORKS
Sunny & HOT ~ Beach barbecue, pool time, raw almonds,
a bad movie on HULU, 5.75 mile run, long afternoon naps.

BENEFITS OF A DRAWING PRACTICE

Think about when you were a child—curious, carefree, and not so critical of yourself. Chances are that you liked to draw or color, but that you stopped doing so at some point along your journey to adulthood. Here's the thing: It is perfectly okay to draw like your six- or eight-year-old self. That might be the age you decided that drawing was not for you, and you gave up on it. You had other interests, it wasn't something you were pulled to, or you didn't have a great art teacher who got you excited about drawing. Or maybe you sat next to a classmate who could draw a dog that really looked like a dog, and that was the day you decided you didn't know how to express yourself with pen and paper, so you might as well not try. All these years have passed, and you really wish you hadn't abandoned drawing. You would love to try again.

The reality is that we can all draw. We can each have a style that's unique and expressive, just like we did when we were kids and everyone in the room had to make a self-portrait: all the kids did it, and they were all wonderful and unique. There is a great children's book called *The Dot* by Peter H. Reynolds that I read over and over to my kids. It is about a young girl who didn't think she could draw. In art class, as a protest, she only drew one dot on her piece of paper. The next day her teacher had her dot hanging on the wall. The realization that this single dot was worthy of being hung sparked her to make dozens of dot drawings, and eventually she has an art show featuring her wonderful dot variations. The message in this sweet story really spoke to me, because I have always believed that anything can be art and anyone can be an artist. I have seen journal pages where the illustrations were all stick figures with words, and I have seen others that are

BOOKS & PLANTS & BOOKS & PLANTS...

all children are artists.
the problem is how to
remain an artist once
he [or she] grows up. -PABLO
PICASSO

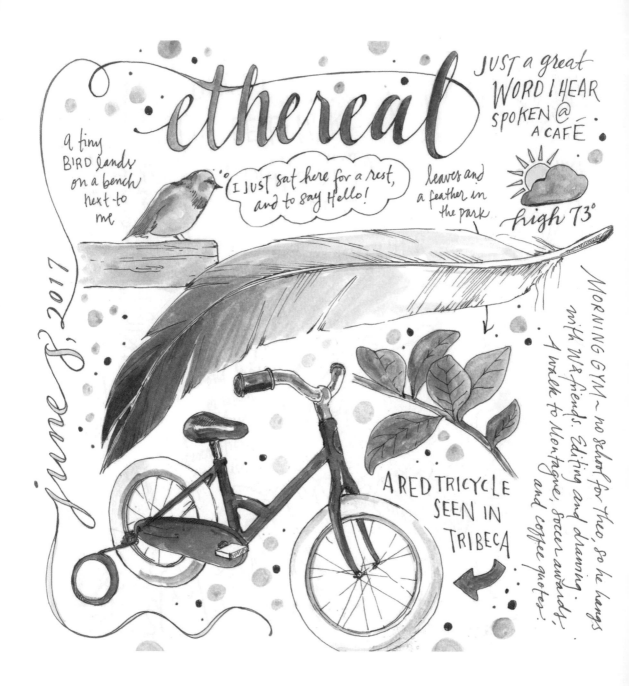

paintings of just color and pattern with notes and feelings wrapping around them. They all look playful and fabulous. Anyone can capture the essence of a day on paper, whether through words, color, collage, or intricate illustrations—no matter their skill level.

Two significant benefits to an intentional art-making practice are stress relief and relaxation. Drawing in a sketch journal should feel like a break, like something to look forward to. Drawing and journaling can free your mind from thinking, "I'm not good at this," as you simply trust that however your pencil or pen marks the page, it will be an extension of yourself—of your mind and your thoughts—and this freedom is so rewarding. Sketch journaling is an opportunity to be expressive in a whole new way. It's a time away from screens, a time to sit with feelings and ideas—to be mindful of how we react and what is important to us to record and remember. The mindfulness, creativity, and patience with yourself that you cultivate through sketch journaling can all seep into other parts of your life.

Another benefit to keeping a visual journal is the sheer enjoyment of looking back at the unique record you've created. Reviewing the days past not only allows you to recall memories of how you spent your time, but it also lets you see how you have developed your artistic skills. We can learn so much from seeing how we used our words and sketches—everything from that amazing restaurant where you celebrated your birthday to the horrible commute you

had when the subway stopped for an hour to the wonder of your child's first step. How did you communicate these things? Would you express those events differently today?

Finding the magical moments in the drawing practice and on the page builds confidence. If you work in your journal every day (or according to whatever schedule you commit to), you will see progress and walk away proud. It's like regular exercise: when you leave the gym, there's a bounce in your step and you feel good about yourself. The same is true for accomplishments in your artistic practice. If you draw your morning coffee each day for a week, for example, and on the seventh day you achieve the type of drawing that you envisioned on day one, you will take that victory and confidence with you into your day, and into the pages of your sketch journal.

the BUDDAH in front of body creams

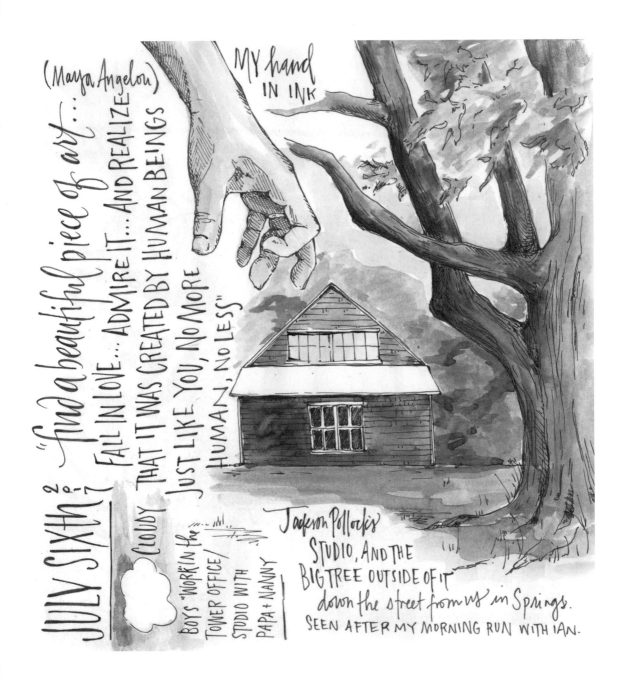

JULY SIXTH²⁷

CLOUDY

(Maya Angelou) "Find a beautiful piece of art... FALL IN LOVE... ADMIRE IT... AND REALIZE THAT IT WAS CREATED BY HUMAN BEINGS JUST LIKE YOU, NO MORE HUMAN, NO LESS"

MY hand IN INK

BOYS "WORK'IN fer TOWER OFFICE / STUDIO WITH PAPA + NANNY

Jackson Pollock's STUDIO, AND THE BIG TREE OUTSIDE OF IT down the street from us in Springs. SEEN AFTER MY MORNING RUN WITH IAN.

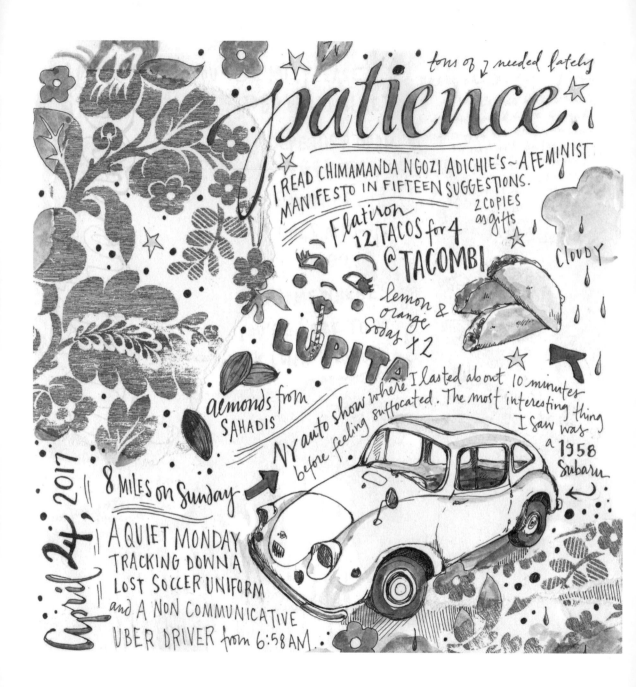

tons of 7 needed lately

patience

I READ CHIMAMANDA NGOZI ADICHIE'S ~ A FEMINIST MANIFESTO IN FIFTEEN SUGGESTIONS.

2 COPIES as gifts

Flatiron
12 TACOS for 4
@TACOMBI

CLOUDY

lemon & orange Sodas x 2

LUPITA

almonds from SAHADIS

NY auto show where I lasted about 10 minutes before feeling suffocated. The most interesting thing I saw was a 1958 Subaru

8 MILES on Sunday

April 24, 2017

A QUIET MONDAY TRACKING DOWN A LOST SOCCER UNIFORM and A NON COMMUNICATIVE UBER DRIVER from 6:58 AM.

CREATE A DRAWING PRACTICE

One of the questions I am asked most often is, "How do you find the time to draw in your journal?" My answer may be surprising: My day is only complete if I spend a little time drawing in my book. Personal trainers tell their clients there is always a way to incorporate exercise into your day, even if it's just twenty minutes. The same is true of the pursuit of any activity. To get better at anything, you have to practice. When there is evidence, a record that improvement is clearly happening, we are compelled to continue what we are doing and the practice can become addictive. That's how it happened for me. When I open my journal every day, I am instantly transported to a peaceful place, but it is a place that also challenges me, which is sort of a magical combination. Sketch journaling is a form of meditation, a way to get to know myself and the world around me a little better.

Over the years, my supportive family has been really helpful by encouraging me to continue my sketch journal practice. My husband and my sons expect me to have my book open, and they even help me think of things to draw. I love reading the inspiring quotes that I put in my journal to my kids, as most of the time the messages are for them. My friends and family help me keep my practice because by now they have come to anticipate me to work in my journal. When we visit friends or meet a friend's dog, they ask me if I will draw some of the events we share or make suggestions for drawings, in hopes they will see something they recognize the next day on my social media post.

Your sketch journal is about your life. Become a looker and seeker; see your hometown with new eyes, highlighting the little things and the not-so-glamorous things that you see each day. There are so many valuable metaphors and lessons in the process of living in the moment. We are able to capture a piece of every day, and realize how lucky we are to have these moments, whether they are good or bad, then turn the page and start fresh again. You see, creating your pages can have a positive effect on the people around you, too—regardless of whether you share the work or keep it private. The time you give yourself leads to perspective on your emotions and helps you understand the people around you with more clarity.

Each person's sketch journal will look a little different, but filling your pages with color and images will help to bring

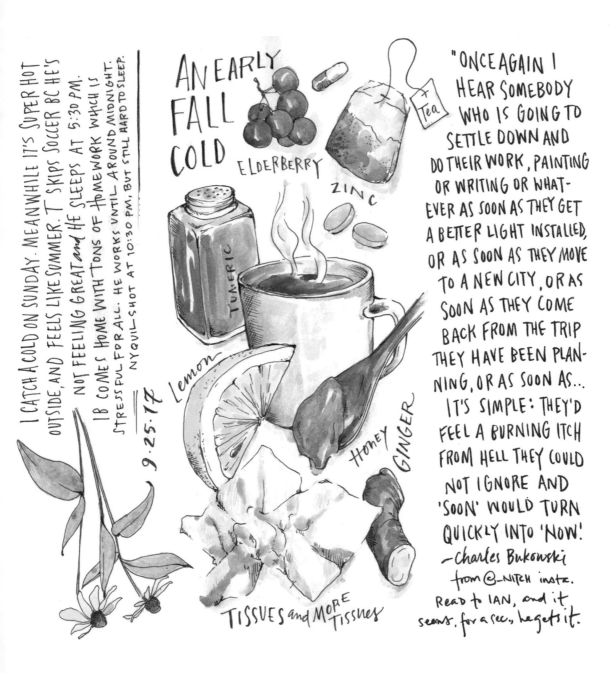

AN EARLY
FALL
COLD

ELDERBERRY

ZINC

TUMERIC

Lemon

Honey

GINGER

9.25.17

TISSUES and MORE Tissues

I CATCH A COLD ON SUNDAY. MEANWHILE IT'S SUPER HOT OUTSIDE, AND FEELS LIKE SUMMER. T SKIPS SOCCER BC HE'S NOT FEELING GREAT and HE SLEEPS AT 5:30 PM. IB COMES HOME WITH TONS OF HOMEWORK WHICH IS STRESSFUL FOR ALL. HE WORKS UNTIL AROUND MIDNIGHT. NYQUIL SHOT AT 10:30 PM, BUT STILL HARD TO SLEEP.

"ONCE AGAIN I HEAR SOMEBODY WHO IS GOING TO SETTLE DOWN AND DO THEIR WORK, PAINTING OR WRITING OR WHAT-EVER AS SOON AS THEY GET A BETTER LIGHT INSTALLED, OR AS SOON AS THEY MOVE TO A NEW CITY, OR AS SOON AS THEY COME BACK FROM THE TRIP THEY HAVE BEEN PLAN-NING, OR AS SOON AS... IT'S SIMPLE: THEY'D FEEL A BURNING ITCH FROM HELL THEY COULD NOT IGNORE AND 'SOON' WOULD TURN QUICKLY INTO 'NOW'.
—Charles Bukowski
from @_NITCH insta.
Read to IAN, and it seems, for a sec, he gets it.

back the big and little moments in your life and will, at the same time, give you a creative release that is healing and confidence building. I grew up around artists and studied art from high school through college, so creating a regular drawing practice came easier to me than it might for others, but it also came after a very long hiatus. I had stopped for many years and had virtually forgotten how to draw. But the way I developed my skills came from practice. I have put pen to paper for at least an hour each day, sometimes for up to eight hours a day, for over three years now. It is important to keep your expectations in check, since my daily routine

might not be realistic for you. No matter what commitment you make for yourself, I know you can become more familiar with drawing and create a beautiful visual journal.

For some people it helps to set aside a regular time each day. Maybe it's with your morning coffee, before you get ready for work. You can set the alarm and spend fifteen to twenty minutes each morning with your journal. Maybe it's after dinner, as a way to unwind from the day. I like to work in my journal at a local café, after I drop my kids off at school, but I also work in bed, as a way to relax before sleep. You can get tools and a lightweight sketchbook to carry with you if it is difficult to set a consistent time each day. It is fun to pull your journal out when inspiration hits. But if standing on a street corner, doodling in a sketchbook doesn't feel comfortable to you, then snap pictures to use as reference

SUSHI DINNER

when you have the time to sit down. You can also keep a small notepad and pen in your bag to make lists of things you'd like to sketch when you have the time.

The important thing is to make the commitment and to have a goal. Commit to ten or twenty minutes a day or even an hour or two, if you're able. Decide to draw one thing each day. Then maybe two things, and so on. Decide that you will fill one whole book in three months or in six months. Decide to complete an entire page for a week, and see how that feels. Once you have made a commitment to yourself, try to consider journaling time a gift instead of a chore—a time you are giving to yourself to reflect and relax, all while improving your communication and creative-thinking skills. This way the promise will be easier to keep.

As with any form of practice, if you find you are not excited to sit down and open your journal, come to it later. Or sit down anyway, and see what happens. Creative journaling is not meant to be a burden on your life, but a way to accentuate, relax, and celebrate. And getting better at drawing can have such a positive impact on the soul and the creative spirit. I would hate to see people begin this practice only to be left with self-doubt and self-criticism. Allow the process to open you up and help you appreciate your beautiful life. You are seeing the world in a new way, and you are developing a personal artistic style. Let the small pages of your sketch journal become a personal lens, a way to organize and creatively make sense of the world around you.

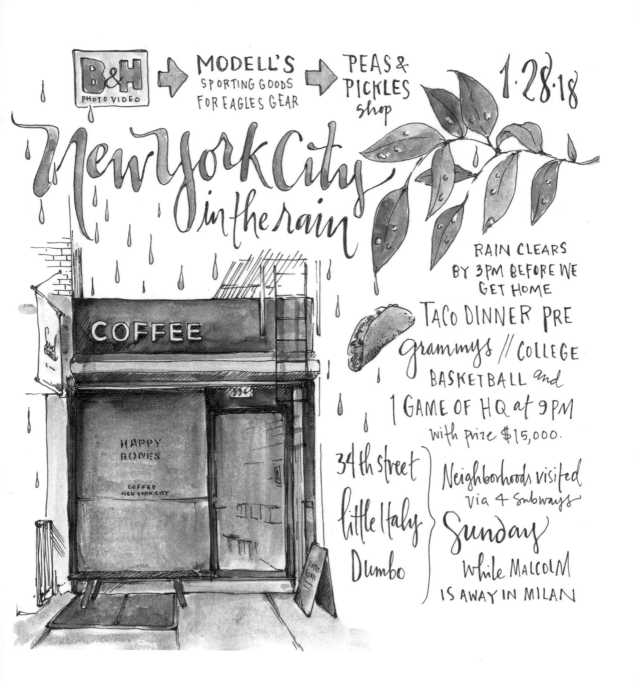

B&H PHOTO VIDEO → MODELL'S SPORTING GOODS FOR EAGLES GEAR → PEAS & PICKLES shop

1·28·18

New York City in the rain

RAIN CLEARS BY 3PM BEFORE WE GET HOME

TACO DINNER PRE GRAMMYS // COLLEGE BASKETBALL and 1 GAME OF HQ at 9PM with prize $15,000.

COFFEE

HAPPY BONES

COFFEE NEW YORK CITY

34th street
Little Italy
Dumbo

Neighborhoods visited via 4 subways
Sunday while MALCOLM IS AWAY IN MILAN

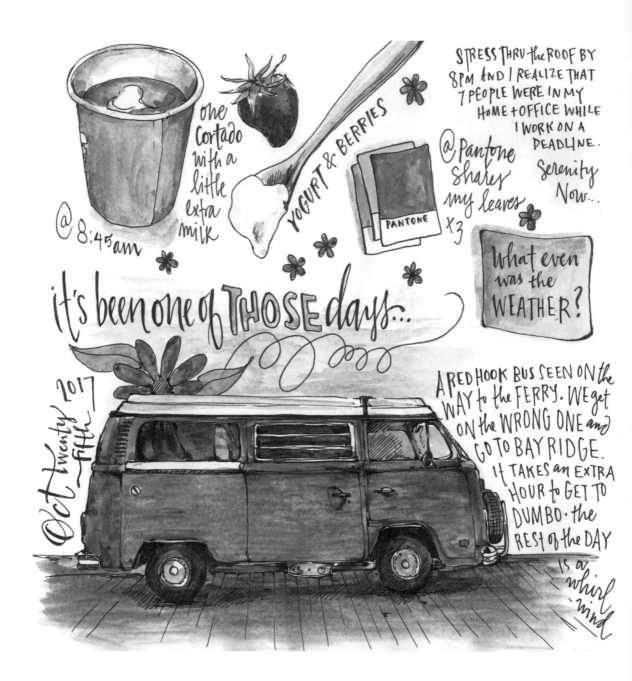

One Cortado with a little extra milk

@ 8:45am

YOGURT & BERRIES

STRESS THRU the ROOF BY 8PM AND I REALIZE THAT 7 PEOPLE WERE IN MY HOME + OFFICE WHILE I WORK ON A DEADLINE.

@Pantone shares my leaves ×3

Serenity Now...

What even was the WEATHER?

it's been one of THOSE days...

Oct Twenty fifth 2017

A RED HOOK BUS SEEN ON the WAY to the FERRY. WE get ON the WRONG ONE and GO TO BAY RIDGE. It TAKES an EXTRA HOUR to GET TO DUMBO. the REST of the DAY is a whirl wind

PANTONE

CELEBRATE MISTAKES

Think of drawing as a muscle, a skill, and a rewarding soul-lifting exercise that needs to be developed over time. Have patience with yourself. When I look back at my journals from a few years ago, they look so different from where they are today. They are not necessarily worse, but they are certainly not as confident. Since beginning my journaling practice, I have filled more than twenty-five books and created more than 1,025 pages of illustrated days. That's a lot of time, a lot of patience, and a lot of little mistakes. But it's all part of the process, and I am excited to see what my pages will look like in a few more years. I know I have a ton more to learn, that I will continue to make drawings I'm not happy with, and that I'll make a ton of spelling errors. I've been known to get the month wrong, forget letters in words, even altogether forget to write the date on an entry.

GOT SOME NEW SNEAKERS

As you practice, the marks will evolve and change, and you will reap the benefits, not only of the results, but of the process itself. Consider making intentional "mistakes": exaggerate your lines; experiment with drawing exercises, like not lifting your pen off the page; or choose something to draw as crazily as you can. Remember that the sketch journal you keep is only for your eyes, unless you choose to share it. So make those mistakes, and start over again. It's by fumbling and repetitive effort that real growth and accomplishment happens. In keeping a sketch journal you are not only keeping a record of your life, but you are also challenging yourself along the way. The satisfaction of looking back over time, tracing your improvements and realizing how much creativity you've freed up, is what it's all about.

Tuesday
MARCH
21 st, 2018

Tuesday
MARCH
22 2018

Tuesday
MARCH
22nd, 2018

If it feels like work, or you are too caught up in feelings of insecurity, take a break and come back to it from a different perspective. Or try another technique. The idea is that the book is a safe, positive, and relaxing place for you to get in touch with yourself and learn to express yourself visually.

Often we will be so hard on ourselves for failing to measure up, that we will close our book and tuck it away in a drawer. It is essential in this process to get comfortable with your mistakes, with skipping a day or two, or with work that looks different from the idea you have in your head. Trust me, even Rembrandt made paintings he wasn't happy with. It is all part of the creative experience. As often as you will put down something you are proud of, you will also put down something you are embarrassed by and want to tear up and throw away, but I urge you not to and instead to simply work around it. Let's say that you really dislike a drawing that you've started. You can leave it there to refer back to, box it off, start again, and maybe write a little note about how you feel about it. Or you can cover it completely with collage or sketch right on top of it with paint and marker. Make the mistakes a part of the process, celebrate them, and even have fun with them.

A blank page can be very intimidating, but you can find ways to push past these fears and challenges in order to reap the benefits of the practice and take the small victories with you throughout the rest of your day. Consider something that is very challenging for you to draw, and also

think of a skill that you've become comfortable with. Then figure out a way to combine the two. Let's say you know you can draw your breakfast easily and in a style that satisfies you, but you have a fear of drawing people (this was me for quite some time). Draw the fruit and cereal, jot some notes down about the day, and then square off a small section for the more challenging practice of working on a person. You can even label it Challenge Day One, Day Two, etc. In that square, draw your friend or spouse or try a self-portrait. This way only part of the page is humbling, and the rest is in your comfort zone. If you work on the challenges a little bit each time you work in your journal, there is no way that you will not improve.

Remember that anything you do is great. You opened your book, you made marks, and sometimes simply that's enough to celebrate. Some days you might just experiment with materials; some days you might attempt to draw something that is completely intimidating. Whatever you chose to do, have fun with the lines and consider that no line is a "mistake" but they are all a part of the journey.

July 19, 2017

a DENTIST APPOINTMENT near Columbus Circle + all ok

FLOSS

one CAPPUCCINO

FEED

(A) x3 Trains to

WE SPEND HOURS REFRESHING CAMP WEBSITE in HOPES WE FIND PHOTOS 2 BOYS • MANY OF T.

NOT SO MANY OF Ian... 3 EPISODES 9 VEEP On WHILE I MAKE this PAGE.

green vegetables

SEE Calder at THE WHITNEY.

DAY 3 WITH BOYS AWAY SO ITS OUR 3RD DATE in a row ~ WE

AND a BIRD and a FERN on the bathroom wall ~ Seen @ 9:00 pm

floor tiles at café Cluny

calder →

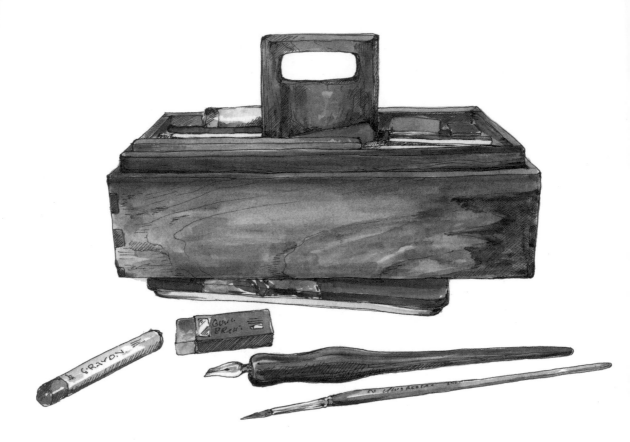

TOOLS AND MATERIALS

I find that it is not the tools that make the art, but the vision—
the ideas behind the created piece—and the process itself.
Just about any tools and materials will work: a few pens, a
pencil, and a glue stick, and you're ready to go. Of course,
it helps to have nice tools you enjoy using and good, durable
paper to work on, so a certain amount of investment is
helpful for beginning a beautiful sketch journal. You can
get started for under thirty dollars, but you can also buy
almost everything I recommend for under a hundred dollars.
It is really up to you and your personal budget, but just
remember that you can simply grab a spiral notebook or a
composition book and let the ideas flow using any working
pen you have lying around.

Finding what works best for you and your own artistic needs
can be a fun exercise, and you should allow yourself the

freedom to explore and try new things. Go to an art supply store and experiment with different pen and pencil brands, trying various weights and colors. Many stationery and art supply stores set out little white pads for exactly this purpose. (I occasionally leave behind little sketches on these pads when I am testing out pens.) As you look, keep in mind that a higher price doesn't always mean it's the best. Some of the most beautiful artwork in journals is created with a basic ballpoint pen or a simple No. 2 pencil. I have some expensive watercolors that were given to me as gifts or that I have carefully selected. But I created most of my pages with a twenty-seven dollar Koi watercolor travel kit. So the fancier supplies can wait as you do some trials with basic tools. In fact, spending a little less at first is beneficial when starting something new, so the pressure and expectation to succeed is less of a burden as you dive in. Once you find you enjoy sketch journaling, and I predict you will, then investing can be more satisfying. Following is a discussion of tools I recommend, starting with the most essential.

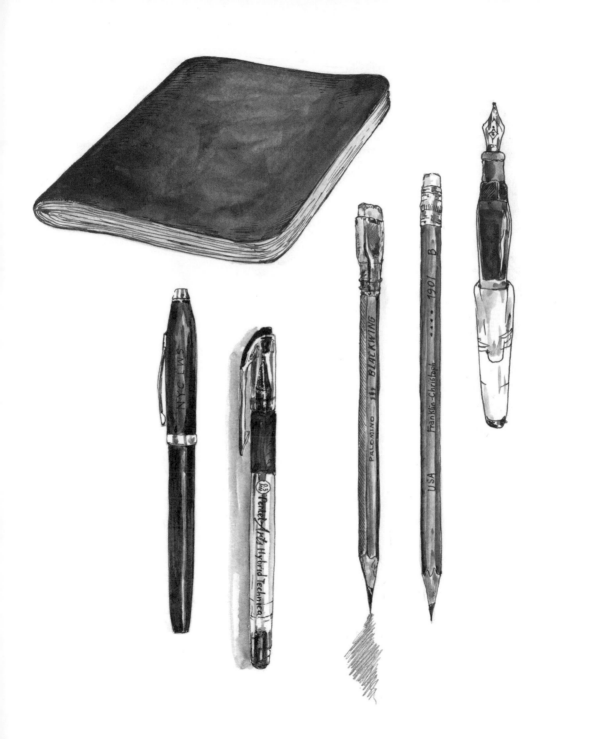

Sketchbook

The sketchbook itself is the first and most essential item
to select. There are so many sketchbooks on the market,
it can be difficult to know what to choose. It's important to
make sure the paper is durable, so it can stand up to many
erasures and can accommodate the color materials you
intend to use. How do you know what the paper can handle?
It's best to ask a salesperson, read reviews online, or make
sure the book clearly states that it's meant for watercolor
or markers. I have used the same type of square Moleskine
sketchbook since the beginning of my daily practice. I love
that I can line all of them up on my shelf, and I like that the
size constraint means that all of my artwork is the same size.
But the sketchbooks I use are not meant for watercolor.
Around journal number five or six, after only using colored
pencil and markers, I decided to give a little paint a try, and
I was so pleased that the paper held up. I don't flood the

page with water, though, and there have been times that the pages wrinkled more than I like, but I am so comfortable with this particular sketchbook style that I just work around this drawback. Someone else might cringe at the thought of watercoloring on paper that's not specifically meant for that medium, but it works for me. The choice is personal, so the best advice I can give you is to go with a book that feels good in your hands, has paper that suits your needs, and is a size that you can easily throw in your bag. If your budget allows, and you find a book you really love, I would also recommend you buy a few of them. Some great sketchbook options are difficult to find or get discontinued. You can even make your own sketchbook to suit your exact needs. The size, the paper quality, the cover . . . your perfect book simply might not exist, but you can make it by following an online bookbinding tutorial. There are many artists and journal-keepers who find this process incredibly gratifying, as their books are an absolute creation of their own.

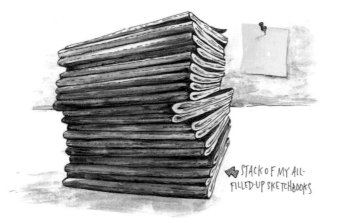

STACK OF MY ALL-
FILLED-UP SKETCHBOOKS

Pencils

I will begin with pencils because I tend to sketch in pencil first (see "Now It's Time to Draw" on page 73) and find pencils to be a great friend to artists of any level, as they allow for mistakes and erasing. I see many people on social media talk about skill level based on lack of initial sketching. But I believe that planning the page composition and the sketch-making process helps not only build confidence before committing to making your artwork permanent, but it can prevent a larger mistake from occurring. So I urge you to embrace the pencil and have fun selecting your favorite.

You can use a regular No. 2 pencil or explore the many variations that are available. Pencils come in different graphite grading scales, ranging from 10H, the hardest, to 10B, the softest. When I say "hard" or "soft" I am referring to how the lead writes—think of the H meaning "hard" and the B meaning "black." A 10H pencil will make a light mark and incise the paper when you push down. A 10B pencil will make the blackest mark with not much pressure, and it will write almost like a soft piece of charcoal. Smack in the center of the scale is an HB, or No. 2, pencil. This is the most common and is what we use in school. The graphite is soft but not too soft and depending on the pressure you can make very light marks and very dark marks. The hardest graphite weight I use is an HB, and 2B and 3B weights are my go-to grades.

Keep in mind that the graphite grades can range slightly among different brands, so I recommend testing lots of pencils out at the shop. In New York City, there is a whole store dedicated to pencils! If you ever have the chance to visit, CW Pencil Enterprise on the Lower East Side is worth the trip. They have a testing table where you can try just about any pencil on the market. Another good place to start is a small sketch set. General Pencil brand, Viking, and Fabriano all make sketch sets, and they typically include a range of pencils from 3H to up to 9B. One of my all-time favorite pencils is the classic Palomino Blackwing 602, which writes much like a 2B pencil. I originally bought a Blackwing because I simply liked the way it looked, but I quickly became addicted because of the smoothness of the graphite. The only downside to the Blackwing is that although some of its charm comes from its signature flat eraser, the eraser doesn't work that well. Another favorite is the Swiss Wood pencil by Caran d'Ache. It is a little heavier to hold than other pencils because it is made with a beautiful beech wood, and the point stays sharp much longer than other pencils I've used. This pencil is a little more expensive than most, but I think it is well worth the cost.

You can also go with a mechanical pencil. Many people prefer these since there is no sharpening necessary. These will typically hold an HB lead in various thicknesses.

Erasers

Many drawing pencils don't have an eraser, and I find that when they do, it doesn't work that well (like the Blackwing pencil I mentioned before). Whether or not your favorite pencil includes an eraser, a good erasing tool is very important and most are just a few dollars. Erasers are usually wrapped in plastic in stores, so selecting the one that's perfect for you can be difficult. While many people choose soft, kneaded erasers for drawing, I get the best results with plastic erasers. With these, I can push down hard without the paper tearing and even lighten a mistake made in ink if I rub it quickly enough before it dries completely. My favorites are a Craft Design Technology 014 plastic eraser and a Seed Radar plastic eraser. A Staedtler Mars plastic eraser is easy to find and is also an excellent choice.

Pencil Sharpeners

If your pencil isn't a mechanical one, then a travel pencil sharpener is essential to have in your pencil case or tool pouch. If you prefer softer pencils and a very sharp point, like I do, you'll be using your travel sharpener often. I find the best are made of brass or magnesium and sharpen to a longer point. I carry a brass bullet sharpener by Möbius & Rupert that costs about five dollars. Before you head out, I recommend the satisfying process of sharpening everything in your tool pouch using a desk sharpener, if you have one. And you can protect the freshly made points with pencil point caps, which cost about twenty five to fifty cents.

pencil point cap

Pens

We all have a pen that we love writing with, right? The type of pen we choose can significantly impact the marks we make. My handwriting completely changes when I use certain pens, and in fact, a pen can change my writing from legible to illegible. I write my snail-mail letters best with a certain roller ball Cross pen a friend gave me about a year ago. I absolutely love writing with it because of how the ink flows and rolls along the paper. I also love an inky ballpoint (even a Bic will do) at times, but you may discover that your favorite pen is not the best choice for all occasions. Some trial and error is necessary when combining ink with other materials. For example, if you want to explore watercolor, the ink needs to be waterproof. (The fine-line pens that I discuss in detail below are all waterproof.) If your favorite pen runs, you can still use it on certain areas of your page where you know you won't be painting. I have a few water-soluble brush pens that I use to write the date, and I am very careful not to then watercolor in that area.

A permanent or waterproof fine-line pen can quickly become your new best friend. As with pencils, there are many pens on the market, so you may want to test out a bunch out to find what feels right to you. Most fine-line drawing pens come in different weights, or line thicknesses, so I recommend a visit to the art supply store to try out the various options. Some artists like to use a Rotring Rapidograph, which is very

spare
nibs

precise, requires care, and is pretty expensive. I find these are too high maintenance for use on the go, although I appreciate how they feel in the hand and the quality of the marks they make on paper. At the other end of the price and care spectrum, many designers and artists use Pigma Micron pens. These are easy to find, inexpensive, and addictive because they come in many colors and weights.

When I write and illustrate in my journal, I like to use a Copic Multiliner or a Pigma Micron, which are both waterproof and easy to carry around in my bag. I use my Copic Multiliner most often with a 0.1 size nib (the part of the pen that comes in contact with the paper), which is thin but not too thin. I prefer this weight because I can add thickness to the lines as I draw. A downside to Copic Multiliners is that the nibs wear down well before the ink cartridge is used up. I can run through about four nibs before the ink cartridge needs to be changed. The nibs come in packs of two, and they are easy to replace with good eyes and a steady hand. I find that the Copic's quality of ink, the way it sits on the page, and the fact that it dries quickly and is fully waterproof makes the effort worthwhile. But then you may not want to risk running out of ink or getting a worn-down nib when you are at a café in the middle of a great journal entry. So if you don't want to deal with managing small parts, I recommend using a fully disposable pen and bringing an extra with you.

Color

Over the years, I have experimented with a range of
materials and have a solid sense of what works well for
adding color to an illustrated journal page. I happen to
prefer watercolor paint, but there are so many possibilities:
markers, colored pencils, water-soluble pencils, water-
soluble pastels, gouache paint, and crayons are also good
options. Following is a discussion of several options for
adding color to your work.

Watercolor

I find watercolor and markers to be the two best materials to transition from black and white sketching to color. Neither material is necessarily easy to use, but both allow for many styles and approaches to come to life on your pages. Watercolor is easy to experiment with because you can add just a touch of color to an area and use washes of color to build up layers as you practice the method. Watercolor is also available in compact, lightweight sets that you can easily carry in your bag. When selecting a travel watercolor set, be aware that there are many levels of quality and price. "Artist" grade watercolor paints have a higher concentration of pure and more expensive pigments, while "student" grade paints may have more fillers and cheaper pigment. The varying sets of watercolor paints can range from twenty to two hundred dollars. It is not necessary to spend a lot if you are using your paints on the go in a journal, because the reasonably priced options suit quick

sketches just fine. If you happen to love painting and want to invest in a nicer set, then by all means, go right ahead. I love all of my paints, and I have a range from highest quality to lowest, but I have a particular attachment to the Koi Pocket Field Sketch Box by Sakura, since it's the set I used when I began to experiment with watercolor. The box is reasonably priced, the colors are vibrant, and it comes with a waterbrush, which is very convenient when traveling. A waterbrush is a plastic brush with synthetic fibers that holds water in the handle. You simply squeeze the handle to get water through to the tip, so no extra water containers are necessary. When you are ready to change color, you just squeeze a little water through the tip, and blot it on a rag or paper towel. These brushes can vary as far as how much water comes out of the tip. I have had to discard a few because they let out either too much water or not enough. They are typically inexpensive, but save your receipt in case you get one that doesn't work well.

On the other hand, if you are more familiar with painting or don't plan to be adding color on the go, you might prefer to use better quality brushes. I recommend getting Red Sable brushes in two or three sizes (Red Sable is an affordable natural haired option, as opposed to a synthetic polyester or nylon brush that will not hold as much pigment or last as long), with pointed tips for getting into tight corners and painting finer details. A good set of brushes can last a lifetime if taken care of. You might want to have one or two flat brushes as well, since these are helpful for edges and filling

large areas with color. Be sure not to leave your brushes in water, because the water can harm the handle and the hairs can permanently bend. After using my brushes, I rinse them well and then let them dry flat on a paper towel or rag. If you opt to use a selection of brushes, as opposed to waterbrushes, when you go out to paint make sure to take along a small container of water and another small empty container (any small plastic container or jar with a tight lid will work): Add a little clean water to the empty container to paint with, and, as it gets dirty, pour it out and replace it with clean water.

An old T-shirt or paper towels are important to have on hand for blotting and for drying your brushes. I like to save my blotting rags in a box because after being saturated with bits of color they become works of art themselves. I am not sure what I will do with these, but the collection is fun to add to and watch grow. These rags can also be used as collage material, which we will get to a little later (see page 83).

Gouache

Gouache, or opaque watercolor, is another great medium to experiment with. These are water-based paints that use brushes and techniques similar to those for watercolor. Working with gouache takes some practice and getting used to if you are accustomed to watercolor, as gouache paint is much more saturated, rich, and opaque, and it can't as easily be blotted away or corrected. What I find so useful with gouache is that you can add layers, building upon the work. You can also use both gouache and watercolor on the same page. I like to begin with watercolor, and then add gouache on areas where I want the color more rich and vibrant. It is also nice to add highlights with white gouache, something you can't do with watercolor due to its translucency. For gouache paints, I highly recommend a beginner's set of Holbein tubes or a palette of pan gouache paints by Caran d'Ache.

Markers

There is a huge range of markers available. I would start with a set of basic primary colors and a set of earth colors. I use Copic Markers, and I love them because the colors are so vibrant and you can layer the ink to get it darker and richer. I received a small set as a gift, and I've added individual colors over time. They are great because, similar to the Multiliners, the ink is refillable. However, Copic is expensive, so I suggest getting a lower priced set to start with, and if you enjoy using markers, upgrading from there. Faber-Castell, Staedtler, and Stabilo make great basic sets of markers.

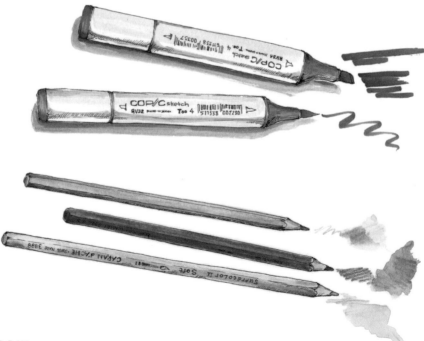

Colored Pencils

I used to use colored pencil much more often than I do now. I find that most are too hard, and to get a really solid area of color, you have to push down with force, which is tiring to my hand. However, there are many colored pencil brands that are much softer and easier to use. Test out a few brands so you can find out if the color goes down thick and opaque enough for your needs. When I was traveling in Italy, I began sketching architecture and buildings, and I purchased a set of Fabriano colored pencils. These pencils are nice for achieving really dark areas of color. Some very good, less expensive alternatives are Faber-Castell Polychromos or Prismacolor Premier colored pencils.

More recently I discovered water-soluble colored pencils, or watercolor pencils. I was given a set of Caran d'Ache Supracolor colored pencils, and I instantly loved them. These can be used just like colored pencils, but with the added benefit that a light wash of water over colored areas creates a soft, blended, watercolor effect. These are great for when you are working outdoors and don't want to deal with paints and water: Just pencil in the colors, then, when you return home, use your brush to add water and release and blend the color.

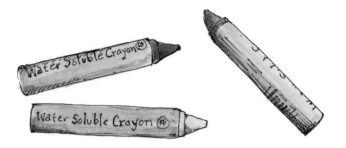

Water-Soluble Pastels

There are several types of pastels available: chalk-like pastels (which come in varying hardnesses, from very soft to very hard), oil pastels, and water-soluble pastels. They are all excellent mediums because the colors are beautifully rich and intense. The color intensity comes from the fact that pastels are made from pure pigment mixed with different binders to form them into their solid shape. I have many fond memories using my chalk pastels in my college figure drawing classes. My hands and nails would be covered in color, and it was almost impossible to keep my clothes clean. But the expressive lines and vibrant color were so worth the mess that was created. In your journal, however, I recommend water-soluble pastels to avoid the residue and messy hands that chalk pastels can cause. Because you are incorporating this practice into your everyday, the mess can be a disturbance, causing smudges on other pages or on your clothes. Caran d'Ache makes a great line called

Neocolor II (these are water-soluble; Neocolor I pastels are water-resistant). They go down very opaque, and are almost like a silky, soft crayon. They are wonderful for making large areas of color and for loose colored sketches. The only downsides are that these pastels are difficult to work with in tight areas and it's hard to get fine details. If you use water-soluble colored pencils and pastels together, you can achieve amazing things, building the thicker pastel lines around the finer colored pencil lines. You can then brush on water washes to blend areas of color together.

Calligraphy and Lettering Pens

I will touch on typography and lettering a little later (see pages 90 and 110), but it goes without saying that words will have a significant presence as you illustrate your days. Certain words you may consider highlighting or making extra beautiful, and the perfect way to do this is by experimenting with your handwriting. If you intend to do any calligraphy (a traditional handwriting skill that requires a very steady hand and a lot of practice) or brush lettering (a more modern approach to traditional calligraphy) in your journal, or if you are interested in getting into it, you can purchase some calligraphy pens and brush pens and experiment with these techniques. I recommend trying a few of the many tutorials you can find online or on YouTube. Calligraphy skills will help you alter your handwriting when you want a word or phrase to stand out on the page.

Brush lettering is a little more approachable than traditional calligraphy; I find the process and outcome more forgiving. It is a real skill, which you need to practice. The basic idea is that the up strokes are very thin and light, while the down strokes are thicker and heavier. It is all about the handling of the tool and a delicate touch. Once you get into a rhythm with brush lettering, the process can be highly meditative and almost like a dance, as your pen makes these beautiful upward and downward strokes. Play some music as you practice. Some of my favorite pen options are the Pentel Arts Sign brush pens, which are ideal because you can write very small with these and they come in great colors. They are not waterproof, however. If you are hoping to paint over the ink, you might want to look for a different waterproof option, such as Tombow Dual brush pens, which are another favorite. These have a larger brush tip on one end and a finer round tip on the other end. Both the Pentel Arts Sign pens and the Tombow Dual come in reasonably priced sets with a range of colored, water-based inks.

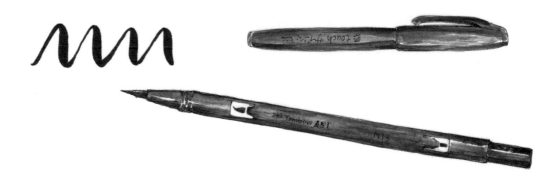

Other Tools

Here is a list of just a few other tools that are helpful to have in your pouch, especially if you would like to incorporate collage or memorabilia.

Glue stick

A glue stick is great to have on hand so that you can glue down paper for collage, ephemera, your ticket stubs or receipts, etc. There are many kinds available, but my favorite glue stick is made by an Italian company called Coccoina. It is difficult to find in local art stores but can be ordered online. When I come across them in specialty stationery and art supply shops in New York, I always buy a few. Another favorite is by Muji and costs about three dollars. Elmer's or Uhu are also fine choices, but I have noticed that they tend to dry up in the tube faster.

Tapes

Washi tapes or colored masking tapes are useful to attach items for collage. Washi tapes have become very popular and are easy to find at art supply shops or craft and stationery stores. These tapes come in an array of colors and patterns, and they are particularly nice to use in a journal, because they can easily be pulled off and stuck back down again if you are not happy with your placement. I have fun blending them into the page, repeating the patterns or color throughout my sketch journal.

Small scissors

You can find a small pair of scissors that you can take with you at a craft or drug store. A pair of nail scissors works fine; just make sure the blades are straight, not curved. The pair I use is from Muji and cost less than five dollars.

Pouch or roll for your tools

To carry around my art supplies, I prefer a waterproof pouch, in case of spills, that is big enough to hold everything I wish to carry. A roll-up case is another great option so that your tools don't bang against each other and the points of your pencils stay sharp. An art roll is a fabric or leather case that has long, skinny pockets to hold individual tools. Once you've put your tools in the pockets, just roll it up into a neat bundle and throw it in your bag. I recommend looking around the art supply store to see what they have. Whether you chose a pouch, a roll-up case, or both, it is a personal choice and can be a fun accessory.

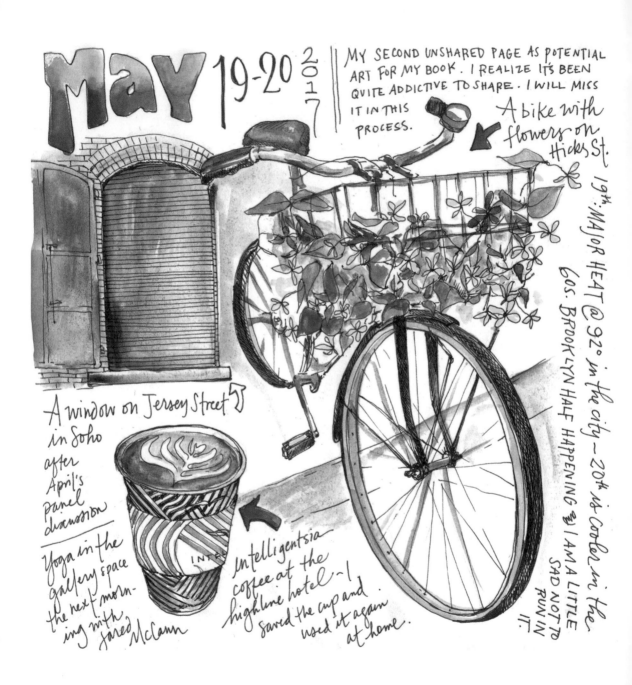

MAY 19-20 2017

MY SECOND UNSHARED PAGE AS POTENTIAL ART FOR MY BOOK. I REALIZE IT'S BEEN QUITE ADDICTIVE TO SHARE. I WILL MISS IT IN THIS PROCESS.

A bike with flowers on Hicks St.

19th: MAJOR HEAT @ 92° in the city — 20th is cooler in the 60s. BROOKLYN HALF HAPPENING & I AM A LITTLE SAD NOT TO RUN IN IT.

A window on Jersey Street in Soho after April's panel discussion

Yoga in the gallery space the next morning with Jared McCann

Intelligentsia coffee at the highline hotel. ~ I saved the cup and used it again at home.

INSPIRATION

For me, the daily drawing practice is a time to reflect and hone in on particular moments—like enjoying a handful of almonds on a subway ride, or the look on my child's face when he tried a new food. Time is so fleeting, and each day passes quickly. Often a week will pass, and I am left thinking, "Wow, what even happened this week? What did I accomplish?" But my sketch journal helps me keep a hold on where my time has gone; it keeps me off of my phone and computer; it reminds me to observe the world around me; and it enables me to look back on it all.

There are two ways I go about answering a popular question, "How do you think of things to draw each day?" One, I live in a big city and I have two kids, and there is always something going on! The days tend to be repetitious, so it's not so much what to draw, but how

to focus on a different item or moment than I did the last time. Which leads me to the second way to answer the question, and that's simply to open my eyes to new ways of seeing things. You get past the moments of sameness by challenging yourself to see them differently. Rather than drawing the same tuna sandwich you bought twice last week from the shop down the road, find one thing on the walk to get the sandwich that might be worth remembering. Was it the laundry you saw hanging in someone's backyard, the sandwich shop itself, the flowers outside the shop, the bag they put the sandwich in? Maybe there is a cookie or a muffin on the counter that piques your interest, and you draw that instead, even if it's not what you ordered. Or you simply say, okay, enough with the tuna sandwich, time to draw (and eat) something else.

A day doing laundry, cleaning the house, only getting outside to go to the grocery store, or having so much work that I don't leave my desk—these are the days that I especially want to breathe life into on a journal page, because these are the days that are typically forgotten, that blend into the week, the month, the year. What if I draw the cobblestones on the street by the market or the lid to the laundry detergent bottle? What if I draw the garbage cans behind our building, which I pass several times a day? What if I draw the food items I bought for tonight's dinner? Pages with everyday subjects like these are the most popular of the pages I share on social media, because we like to find ways to relate to each other through the ordinary.

Our morning routines, breakfast, a doorknob never before noticed, or a coveted pair of shoes. There is great comfort in focusing on these familiar items and recording them on the page.

Why can't a peek in a window be captured in a way that preserves that moment in time? For example, I saw an adorable kitten in a window during a morning run, and it was so sweet, I had to draw it. Now the tiny kitten will forever be in my book. A lot more happened that day, but I chose that particular moment to illustrate. Of course, you will have days that are crazy busy—running errands, visiting with friends, traveling, perhaps seeing a spectacular natural sight like a mountain. These days can be savored for obvious reasons.

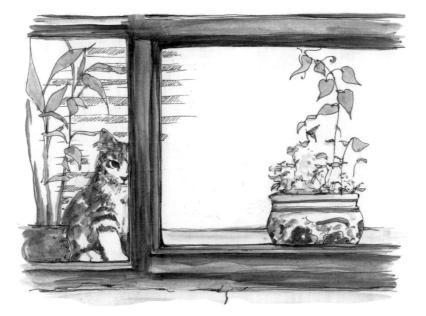

But you will find that if you share a bit of the unexpected from each day, whether something significant happened or not much happened at all, when you look back you will remember. You will remember the day you worked at the computer, did four loads of laundry, and went outside for a quick walk. That doesn't sound like the most exciting day, does it? But when you capture a carefully chosen glimpse of this fleeting day, then suddenly, at least on paper, that day is made memorable. It was an ordinary day preserved on a single page.

It is important to me to identify and include the idea of the everyday, the mundane, through my process. As you flip through this book, you will find some big ideas and big things illustrated, but each page has bits of the ordinary, too: the things we do each day, the foods we eat, the cars and buildings we pass by on a regular basis, the dog we pat in the park. I am lucky to live in New York City, to be exposed to so many different cultures and people, and to be able to run across the Brooklyn Bridge each morning, but it is not the bridge that I want to highlight. It's the little things that make up a day. A sad day, a happy day, a milestone day, a holiday, a sick day—all of these days are filled with tiny moments that, when drawn or written about, will help transport me back. And you can achieve the same thing by being attuned to the beauty in the small details of your life and recording them in your journal.

To help inspire ideas, I tend to look back on the pages I have created while traveling. When we are away from home, I am

even more aware of what we are doing and seeing, and I feel a heightened desire to capture memories in my journal. I often use a particular example when explaining how I get inspired: When my husband and boys and I climbed the stairs of the Eiffel Tower in Paris, it wasn't the Eiffel Tower that I chose to emphasize on my page, but rather the ham and cheese croissant that my youngest son wouldn't eat. He would not eat anything on that trip to Paris, and it caused emotional turmoil for the family. That's what I want to remember in my journal. Of course, we will remember climbing the Eiffel Tower, but years later, I will relish remembering how frustrating it was to get my son to eat!

When you walk around your town or city, pay attention to the things that catch your eye. It's fun to examine a moment or a place, and think about how you can record it on paper. The pastries you eyed as you ordered your morning coffee at the corner bakery, the book or magazine you considered buying if only you had more time to read, the condensation on the leaves from the rain and humidity. These things are easy to capture with small notes or small illustrations. You may have such a strong routine built into your life that it is difficult to think about sameness in different ways. For example, you might have a desk job, and the same commute to your job each morning: You wake up, shower, eat some breakfast, drive to work, work eight hours, drive home, have dinner, sleep, and then you do it all over again. If this type of situation is one you can relate to, think of playing games to add excitement. Maybe you go through the same five traffic

lights on one road each day. You can count how many times you had to stop. Make a mental note, and jot it down in your journal. Drawing the five traffic lights, mark how many were green, yellow, or red during your drive. Did you make the subway, or did you just miss it? Was it a jam-packed train? Did you have to stand? Think about all of the shoes gathered around yours, packed into the same small area. Are you wearing a new pair of shoes? Are there any other shoes on the train that you would like to own? What are the ugliest shoes you see? Did you see someone wearing a pink hat across the street? Did you spot a business card or a coin on the sidewalk? It's the little things that we take for granted because all we see is the same routine.

A PIECE OF GUM and Blackberries

plain black shoes

At work, you can think about the events that fill each hour—the phone calls you make, something that made you laugh, your frustrations with a colleague or your boss—and challenge yourself to find ways to communicate these feelings and events in your journal. Every day is filled with small moments that can be sketched. Perhaps you had a really busy day with some bad news, or maybe there is a work situation that is driving you crazy—bring those feelings to your journal. Grab some crazy patterned wrapping paper that you saved in your drawer for collage, tear it up into little pieces, and glue them down in a circle. Then take your crayons or markers and make marks all over. I promise that the page will bring you peace, power, and creative release. Then you can jot down, small, in the corner, what made you express yourself in such a way. The most frustrating day can become beautiful and expressive on this one page. Then, the best feeling is to look at that page, take it in, and then turn it over. A new blank page awaits and will be tackled with completely new feelings and attitudes.

an art
supply receipt
on my desk

There are many ways to approach composing an illustrated journal page. A good place to start can simply be writing the date. If it's a holiday or someone's birthday, you might want to add those details as well. Doodle a small birthday candle or cake with the name underneath: this can be your go-to visual reminder for birthdays. Is there something significant that is going to happen on this day? Are you nervous or excited? You may want to have a designated "feelings" corner of the page and create your own visual cues for recording your feelings.

Some of the most beautiful journals I have seen have elements or illustrations that are repeated on each page. Although my pages tend to all look very different, I repeat many elements over and over. For example, I am personally affected by temperature changes, and I can remember moments based on feeling cold or warm or wet on a specific day, so I find it very helpful to record the weather. Using repeated patterns can create continuity

as you look through your sketch journal and can also take some of the pressure off when facing the blank page. For example, the upper left corner could always have the date, weather forecast, and a feelings chart. Next to that, the number of cups of coffee or tea you drank. Next to that, a sleep chart sharing how many hours of sleep you got the night before. Then, below, a drawing of one interesting thing that caught your attention. Or two things, or three. By just starting to draw a repeated element when you begin, you can avoid the intimidation of a blank page.

Some things you can draw or write about on ordinary days are:

COFFEE CAN OR BAG

TEA BAG OR TEA BOX

YOUR FAVORITE COFFEE MUG

FOOD

FAVORITE SWEET TREATS

ITEMS FROM THE GROCERY STORE

CANS OR BOTTLES

FLOWERS

TREES AND PLANTS

FALLEN LEAVES

BUGS

BIRDS

ANIMALS

MAIL IN YOUR MAILBOX

THE WEATHER

BIKES

SIGNAGE

VINTAGE CARS

STOREFRONTS

STREET SIGNS

ROAD MAPS

MAGAZINES

BOOKS

EXCERPTS FROM BOOKS

A NEWS HEADLINE

MEANINGFUL QUOTES FROM
CURRENT EVENTS

SONG LYRICS (THIS IS GREAT FOR
PLACING YOUR ILLUSTRATION
IN TIME)

THE FRIEND YOU HAD LUNCH WITH

A CLIENT PHONE CALL
(GREAT FOR MARKING TIME)

THE ART SUPPLIES YOU USE
TO CREATE YOUR PAGES

- DOCTOR'S OFFICE TOOLS OR RECEPTION DESK

- BARBERSHOP OR SALON APPOINTMENTS

- GROOMING TOOLS LIKE YOUR HAIRBRUSH OR TOOTHBRUSH

- MAKEUP

- NEW SHOES OR A NEW CLOTHING ITEM

- FOUND PATTERNS

- PRODUCT PACKAGING

- RECEIPT FROM YOUR DRY CLEANING

- TICKET STUBS (YOU CAN GLUE THESE IN OR DRAW THEM)

- . . . IT'S REALLY ENDLESS.

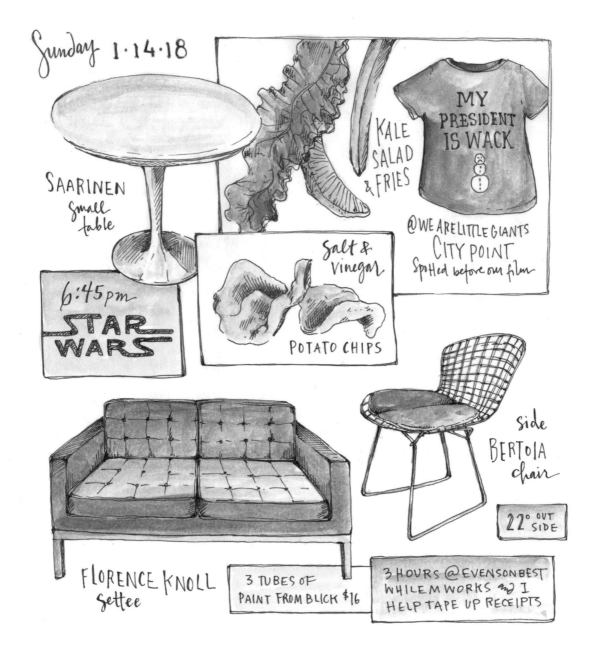

Sunday 1·14·18

SAARINEN
small
table

KALE
SALAD
& FRIES

MY
PRESIDENT
IS WACK

@WEARELITTLEGIANTS
CITY POINT
Spotted before our film

6:45pm
STAR
WARS

Salt &
Vinegar

POTATO CHIPS

side
BERTOIA
chair

22° OUT
SIDE

FLORENCE KNOLL
Settee

3 TUBES OF
PAINT FROM BLICK $16

3 HOURS @ EVENSON BEST
WHILE M WORKS and I
HELP TAPE UP RECEIPTS

Two scenarios: I have a friend who is very high up at a music company. She has a team of people who report to her. She also has two young daughters, is on the PTA at school, goes to events at least three nights a week, and somehow manages to have coffee with me a few times a month. Her life has so much material for a sketch journal; I would have a blast illustrating her days! Another friend is a writer, has no kids, and works from home. Sometimes she doesn't even change out of her pajamas all day. You would think she wouldn't have as much material and inspiration as my other friend, right? But let's play with this example: My writer friend wakes up, feeds her cats, makes some coffee, listens to NPR while having a bowl of cereal, and then sits down to write. She basically does this every day when she has a book deadline. Day after day. How can she take a break and fill a sketch journal with various illustrations if she does the same thing every day? But there is more in her day than meets the eye: her hours of sleep, the scene from her window, the dish she prepares for dinner, the ideas she has for her book, the feelings she generates from her creative process, the weather, something she sees on a short walk to get some fresh air, a product in her makeup bag, a story she hears on the news, her shoes, her dreams for the future, and so on. You see, there is always something to draw, no matter where you live or what you do.

If you Hear A Voice within you Say 'I cannot paint,' then by ALL Means paint. AND that Voice will be Silenced.

-Van gogh

NOW IT'S TIME TO DRAW

In this chapter I first talk about my basic process for creating a page, which is always evolving but usually begins the same way. As you get into your own sketch journal routine, you'll find the processes that work best for you, which may change over time as you develop your practice. If any of the processes you try ultimately don't work for you, feel free to move on and try something else! For example, sketching things out in pencil may not work well for you. If it doesn't, skip it. On the other hand, you might enjoy working in pencil and watercolor, without any ink at all. It's all about what works best for you and inspires you to just get drawing.

The Process

On the following pages you will see a handful of pages in different styles of completion, starting from the initial pencil sketch to the fully painted and colored page.

Most of the time I tackle drawing pages in three simple steps. First, I do a loose sketch in pencil; second, I go over the pencil in ink; and third, I add color. These three steps can be broken down into more steps, which I will guide you through.

Pencil Sketch

Once I figure out what subjects I want to draw, I begin to plan the actual arrangement on the page. Remember that there are no hard composition rules for a journal page; there are only endless options. In my opinion, it is best to start this planning process in ordinary pencil. I tend to use the pencil marks as a loose initial guide, but you might

choose to spend more time working in pencil to get you a bit closer to finished shapes. Just make sure that your pencil marks are light enough to erase well. Think about how many big things you want to fit on the page. I usually select three or five things, since odd numbers tend to look a little bit better in groups. Maybe I am really interested in that awesome old car I saw parked on my street, so I begin drawing it, knowing that I can figure out the rest of the content later. Or I may start by drawing the date in one of the four corners of the page. Or occasionally I will throw this pattern off by writing the date in the center of the page and working around it. It gives me comfort to have a few elements down on the page, and then I can add shapes to the remaining space. If I want to illustrate the elephant at the zoo, I make sure that the elephant is surrounded by some space to breathe, so the eye can focus on that drawing. Big elements surrounded by small areas, to write captions or explain where I saw the elephant, are key to a balanced page. A big pop (the primary shape), and then small touches (other objects and details) to examine and take in help bring me back to that day.

Sometimes I draw little squares or circles in very light pencil to assign places for things. You can even lightly label what you will draw in each section—"large pink flower I saw in the park," "a new dress," "the joke I heard last night," and "weather"—one large circle for the main illustration and small circles around the page for everything else. If you compartmentalize the big and little things you want to

capture, it's visually exciting for these elements to bleed or seep into other sections. Maybe you ate a bunch of carrots for a snack, and they were so sweet and delicious, you decide to draw a carrot in the corner. You can draw the carrot so it creeps into the space where you intend to illustrate a pile of magazines you haven't had time to read. I love completely random pieces of my days, with no visual connection, falling next to each other and creating a relationship on the page.

Don't be afraid of the edges of the page. Think of the page as a viewfinder; there are elements that fall outside the frame. It is more than okay to have drawings bleed right off the sides. If you start a drawing of a bike in an empty area but you drew it a little too big, you can just let it fall right off the edge of the page. Bleeding images make the composition more interesting, and you might be surprised by how much that edge of the page becomes your friend and helps to bring your artwork to life.

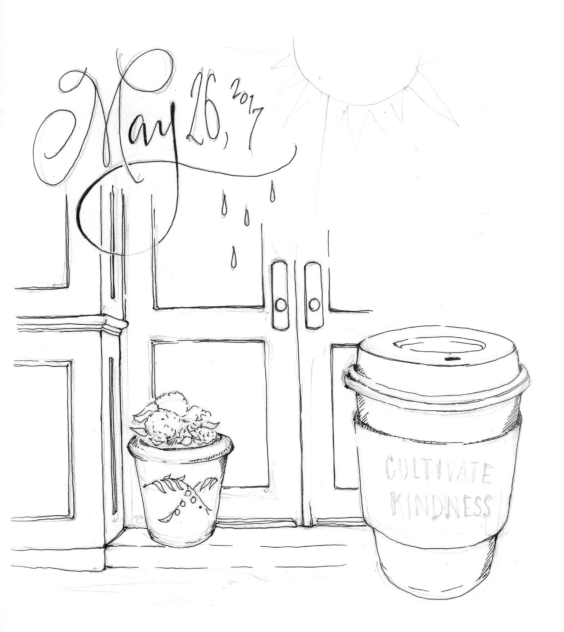

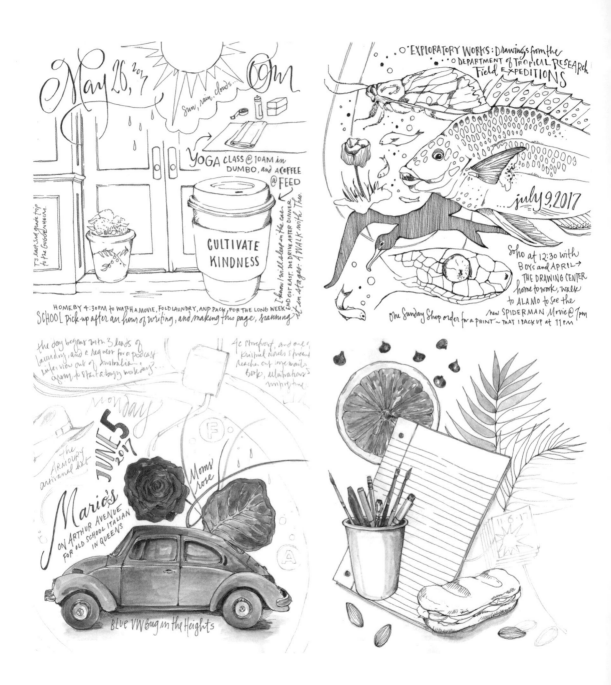

May 26, 2017

Sun, rain, clouds...

9 AM

YOGA CLASS @ 10AM in DUMBO, and A COFFEE @ FEED

CULTIVATE KINDNESS

T's 3rd-2nd grade trip to the GUGGENHEIM.

I know I will sleep in the car. END OF EAST. WE DRIVE AFTER DINNER. It's an 8 hr drive: A WALK with Theo.

HOME BY 4:30PM to watch a movie, fold laundry, and pack, for the long week. SCHOOL pick-up after an hour of writing, and making this page, scanning.

EXPLORATORY WORKS: Drawings from the DEPARTMENT of TROPICAL RESEARCH Field Expeditions

july 9, 2017

Soho at 12:30 with BOYS and APRIL → THE DRAWING CENTER home to work, walk to ALAMO to see the new SPIDERMAN Movie @ 7pm

One Sunday Shop order for a print ~ THAT I PACK UP at 11PM

the day begins with 3 loads of laundry, and a request for a podcast interview out of Australia - dream to start a bougy work day...

4c storefront, and our Knitted Novels & friend reaches out once more. Book, illustrations inspire her.

Monday

JUNE 5 2017

the ARMOURY artisanal art

Mario's ON ARTHUR AVENUE FOR OLD SCHOOL ITALIAN IN QUEENS

Moms rose

BLUE VW bug in the Heights

Adding Ink

After you have sketched things out and you have a handle on what the page will look like, you can go over the pencil lines in black pen or in colored markers. Drawing in ink can be nerve-racking because it is permanent. There's no way around this other than to just go for it. If you make a mistake, that's okay: you can turn it into something else. Try working on all of your outlines first and add shading after. There are a few ways to add shading or depth to ink drawings. Stippling is the process of adding small dots to create value or depth. The more dots, the darker the area. This is a time-consuming process, but if you have the time and patience, the results are beautiful. Crosshatching is usually how I create depth with ink. It's the process of drawing overlapping parallel lines in one direction, and then drawing lines across those in another direction to create darker areas. The closer the parallel lines are to one another, and the more lines you cross over each other, the darker the area becomes. I also tend to go over the outlines of shapes on one side of an object or letter to create some depth, and then I build from there.

Next, erase the pencil marks underneath. But be sure to wait long enough for the ink to dry completely before erasing the pencil. I have often erased too soon and created smudges I have had to work around or try to fix.

crosshatching

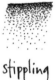

stippling

Color

Once the ink is down, it's time to add color. I paint my pages with watercolor, adding touches in gouache here and there. But you can use any of the many materials and tools for color (see pages 44 to 53). Learning to work with watercolor is a special skill, so it takes practice. I recommend experimenting on scrap pieces of paper to understand what you can do with brushes, varying amounts of water and paint, and what you can get by mixing colors, etc. Discovering what happens when watercolor paint is diluted with varying amounts of water is something that is difficult to describe. It is best to begin with more water so that the pigment goes down in a very soft wash on the paper, and then, once that has dried, you can build more solid color on top. If you apply a light wash of color on an object, you can also build darker layers of paint around the edges to create depth. It takes practice, but after trial and error, and perhaps some online tutorials, you will get the hang of it. Also feel free to mix watercolor paints with other mediums. I like to experiment with applying dark lines of color by using water-soluble pastels or my markers on the edges of drawings. You can also write words right on top of softer watercolor drawings using markers, pens, or pastels that make dark, vibrant lines.

I often like to create a color palette for the page. If you would like to illustrate a supermarket shopping bag, for example, and the bag is a basic tan paper-bag color, then

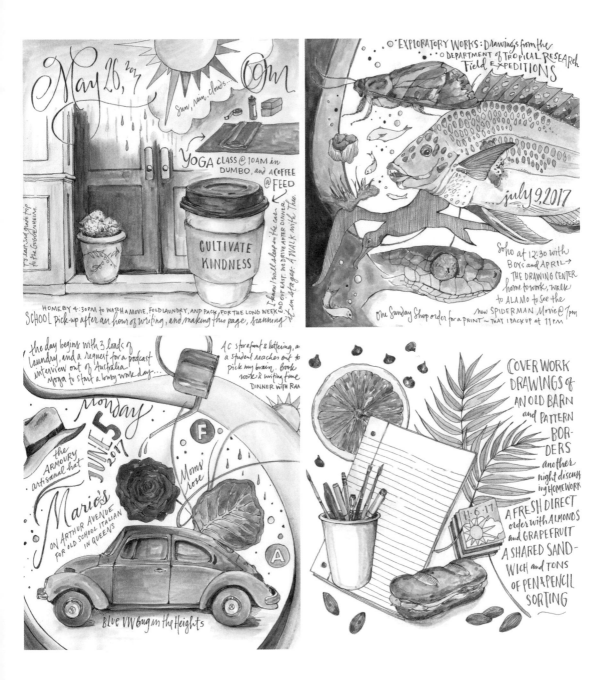

think about using that color not only for the bag but again for other details on your page. This helps create balance and continuity. Did you buy some asparagus at the market and eat them for dinner? You could use light green as the main color for that day. Even if nothing else is green, you can bring green onto the page in another area by coloring in the date or drawing a green line to separate thoughts. Or you could think about filling in the empty areas with patterns that relate to the drawings. If it was a rainy day, I often fill in areas with raindrops, for example. Or if I want to repeat a main color, I will paint dots of that color to balance the page.

Color is a great way to express a mood. It can also trigger a memory. I have had blue days (calm and reflective) and yellow days (energetic); I have days when I am struck by the colors of leaves changing or how blue the ocean water is, or how blue my son's tongue gets when he has a ring-pop that the barber gives him. Using certain colors can also change your state of mind. If you are having a hard day, try to find solace in your drawing practice: Instead of using grays and blacks, consider using bright red and orange to bring you energy and optimism. You can jot some notes down about why you chose to work with the colors on that page.

Collage

Collage is a really fun and effective way to accentuate a journal page and is an artistic process that is very freeing no matter how much experience you have with making art. I have been playing with patterns and collage since I was a little girl, when I would make cards for my friends with patterns drawn around photographs. Now I keep a box in my studio filled with items perfect for collage: torn papers, wrapping paper bits, paper samples from paper distributors from my design days, and magazine clippings of found patterns. I often glue a piece down on my page, draw in the date, and then the page flows from there. If there is a pattern on the paper I used, I will echo parts of it elsewhere on the page so that the torn pieces become camouflaged on the page.

Many journal-keepers glue down ticket stubs or receipts in their books, which is a great way to remember special events. But let's take it a step farther. Why not layer the receipt over a torn piece of the tablecloth or menu (of course I don't encourage stealing menus, but you can snap a photo, print it out, and cut out the part you want to use). Many restaurants have paper on the tables, and they supply crayons for children to use. You can ask for these crayons or pull a pen from your bag. Play a game of tic-tac-toe with your friend and save it. Or write the date, names of the people you ate with, and a small drawing of your food choices, and take it home. Maybe the business card of the

restaurant has a pretty pattern on one side. If so, you can separate the layers of the card—I use my fingernail to pull apart the front of the card from the back, so that the paper becomes thinner—and glue it down. Then you can illustrate the restaurant's logo on top of the torn business card.

If you see a play, tear pieces of the theater program, and glue your ticket stub on top of them. If you see a movie, and eat Junior Mints, tear off a piece of the box, and throw it in your bag to glue down later. The possibilities of how to incorporate collage are endless. I would consider keeping a box for this purpose, so you always have a file of inspiration and materials for your sketch journal ready. Anything flat can be glued down on your page. A beautiful wrapping paper may be the most obvious choice, but anything from a chewing gum wrapper to a ticket stub to an old photograph will work (see the list on page 87 for some more inspiration).

Gluing down small pieces of colored paper is a great way to tie in the dominant color. It's fun to create a mood or have ideas and drawings flow from a chocolate wrapper or a piece of a shopping bag. Some days, when I don't know exactly what I will draw on my page, or I am feeling a little less focused, I begin with a collage process and build from there. The pages of a journal that have layers and glued-down papers are wonderful to touch and flip through. The examples shared in this section have a very different look and feel in real life.

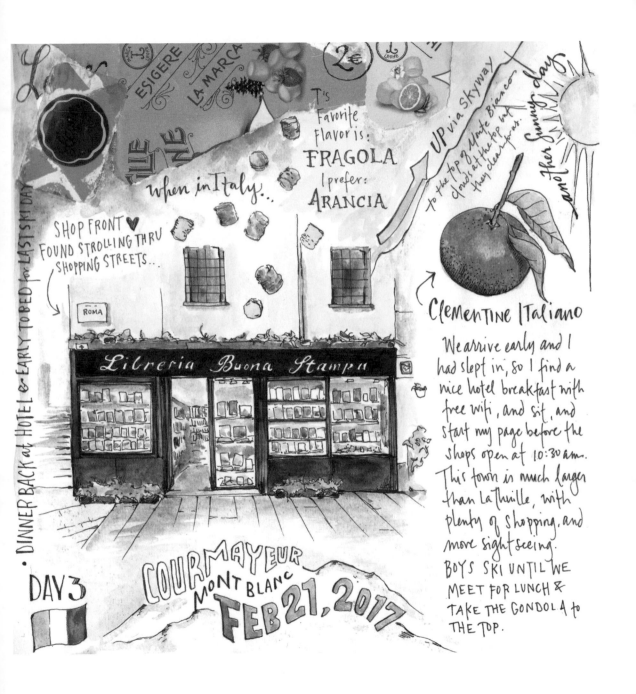

ESIGERE
LA MARCA

When in Italy...

T's
Favorite
Flavor is:
FRAGOLA
I prefer:
ARANCIA

UP via skyway
to the top of Monte Bianco
clouds at the top but
they clear up fast.

another sunny day

SHOP FRONT ♥
FOUND STROLLING THRU
SHOPPING STREETS...

ROMA

Libreria Buona Stampa

Clementine Italiano

We arrive early and I
had slept in, so I find a
nice hotel breakfast with
free wifi, and sit, and
start my page before the
shops open at 10:30 a.m.
This town is much larger
than La Thuille, with
plenty of shopping, and
more sightseeing.
BOYS SKI UNTIL WE
MEET FOR LUNCH &
TAKE THE GONDOLA to
THE TOP.

• DINNER BACK at HOTEL & EARLY TO BED for LAST SKI DAY

DAY 3

COURMAYEUR
MONT BLANC
FEB 21, 2017

Maker's Mark WHISKY

IRISH WHISKY

Amazing afternoon light

IT'S COLD BUT →

30 yd.

8

Fulton

Poplar

Middagh

Cranberry

Orange

Pine Ap.

Clar.

Love.

Willow

@ 4:30 pm.

NEW-YORK

AND

BROOKLYN.

26·17

Moist Opaque Colors for Backing Negatives

Things you can use for collage:

VINTAGE STAMPS OR USED STAMPS

BUSINESS CARDS

SHOPPING BAGS OR LOGOS
FROM SHOPPING BAGS

RECEIPTS

TAKEOUT MENUS

CANDY WRAPPERS

PACKAGING (I PEEL THE TOP LAYER
OFF OF ANY THICK PACKAGING
PAPERS)

WRAPPING PAPERS

MARBLED OR PATTERNED PAPERS

COLORED TISSUE PAPERS

WASHI TAPES OR OTHER FUN
COLORED TAPES

GREETING CARDS

PHOTOGRAPHS

MAGAZINE CLIPPINGS

OLD NEWSPAPER ARTICLES

DRIED LEAVES OR FLOWERS

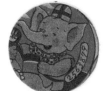

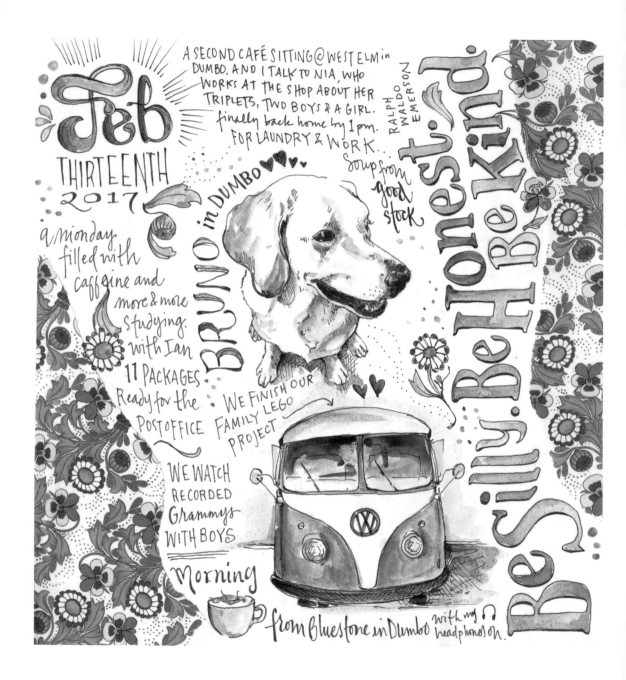

Feb

THIRTEENTH 2017

A SECOND CAFÉ SITTING @ WEST ELM in DUMBO, AND I TALK TO NIA, WHO WORKS AT THE SHOP ABOUT HER TRIPLETS, TWO BOYS & A GIRL. finally back home by 1pm. FOR LAUNDRY & WORK...

Soup from good stock

RALPH WALDO EMERSON

Be Honest. Be Kind.

BRUNO in DUMBO

a Monday filled with caffeine and more & more studying. with Ian 11 PACKAGES Ready for the POST OFFICE

WE FINISH OUR FAMILY LEGO PROJECT

WE WATCH RECORDED Grammys WITH BOYS

Morning

from Bluestone in Dumbo with my headphones on.

Be Silly. Be

IDEAS FOR DRAWING

Typography and Signage

Words and numbers will no doubt be a feature of your journal pages when you are drawing your day, so you might as well have fun with them. Because of my design background, I am constantly inspired by letterforms. When I started my journal practice, I often just doodled letters, patterns in letters, or made patterns into letterforms. I studied design at Cooper Union, which is a pretty serious place when it comes to typography. They taught us in a very traditional way, studying typefaces by drawing them by hand with black paint to understand the nuances of the different serifs and curves. My typography professor had us learn to identify all of the classic typefaces based on these exercises. Knowing typography isn't necessary, but it can be useful when attempting to play with lettering. You can look online for a diagram of each letterform, to give you a basic understanding of the features of each, especially "serif"

(with short lines extending from the letter lines) and "sans serif" (without these lines). Or simply look at the typefaces in a magazine or on a box of pasta, and take mental notes on the differences you notice.

Play with your own handwriting, adding weight to the downstrokes and playing with placement of the cross line on a capital A or capital H. Drawing the cross line higher or lower across the up- or downstroke can change the vibe of the letter completely. Have fun making the words and quotes you write on your pages look interesting by forming the letters in unique ways. You can explore typography, lettering, and signage easily online. Search "vintage alphabets" and see what comes up. Or, better yet, go to a bookstore and look in the design and typography section. You'll find so much inspiration in these books. Another great thing about working with letterforms is that they can be so expressive and also so forgiving. There is truly no wrong way to draw the letter A, and the variations are endless.

AUGUST 26 · 2017 // 2X VISIT TO chutney

A BETTER SLEEP ZzZz
all the ladies head out
to the yard sales at
9:30 AM

SUNSHINE
and a NEW BRACELET with a

A fish from a VINTAGE TIN BOX found at an

OCEANIC
yard
Sale

FROM Vernacular.etc. · 6 leaves from BK

A LATE MORNING SPIN

MORE SPORTS gear and DINNER with
BECKY and IONA on Stony
Hill ~ with a BALSAM
FARM salad

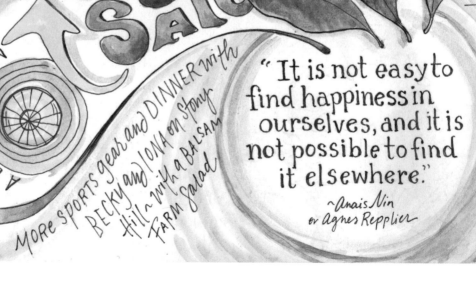

"It is not easy to
find happiness in
ourselves, and it is
not possible to find
it elsewhere."

~Anais Nin
or Agnes Repplier

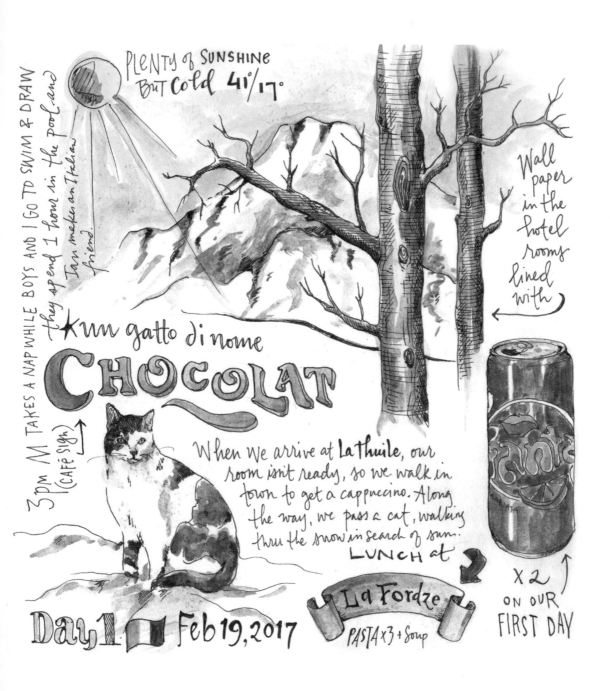

PLENTY of SUNSHINE
But Cold 41°/17°

I am make an Italian friend.
they spend 1 hour in the pool and
BOYS AND I GO TO SWIM & DRAW

3pm M takes a nap while

un gatto di nome
CHOCOLAT

(CAFÉ SIGN)

When we arrive at La Thuile, our
room isn't ready, so we walk in
town to get a cappuccino. Along
the way, we pass a cat, walking
thru the snow in search of sun.
LUNCH at

Wall
paper
in the
hotel
rooms
lined
with

× 2
ON OUR
FIRST DAY

Day 1 ▪ Feb 19, 2017

La Fordze
PASTA ×3 + Soup

Weather

The weather, especially if it is extreme, can alter the flow or mood of a day, so it's a perfect visual element for a journal page. Some days the weather can be a small detail, and other days it can be the main focus of the page. I love my journal pages on rainy days. Probably because a raindrop is such a great shape to draw. You can make raindrops big or small, light or dark, running straight up and down the side or on an angle. You can draw puddles and umbrellas, or muddy wet rain boots, or a dripping raincoat hung by the door.

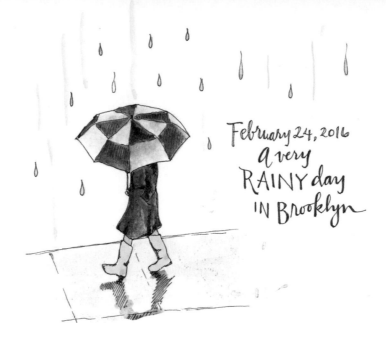

February 24, 2016
a very
RAINY day
IN Brooklyn

Sunshine, the shape of the sun, the shape of clouds, snow falling, footsteps in the snow—connecting the weather to an overall mood is a great way to illustrate a day. A gray, rainy day can dictate how the whole page looks and feels. I think of the hot, steamy summer days, when the rain finally breaks the humidity. Drops of water communicate not only the rain, but the condensation on a water bottle or the sweat on your forehead. At the other extreme, I think of those freezing-cold days when you're not sure whether you want to go outside. You could draw the snow, the icicles, a frozen teardrop on your face as you walk through the blustery streets, or looking at the snow from indoors, while sitting near a fire. As you can tell, I get excited just thinking of different ways to illustrate the weather.

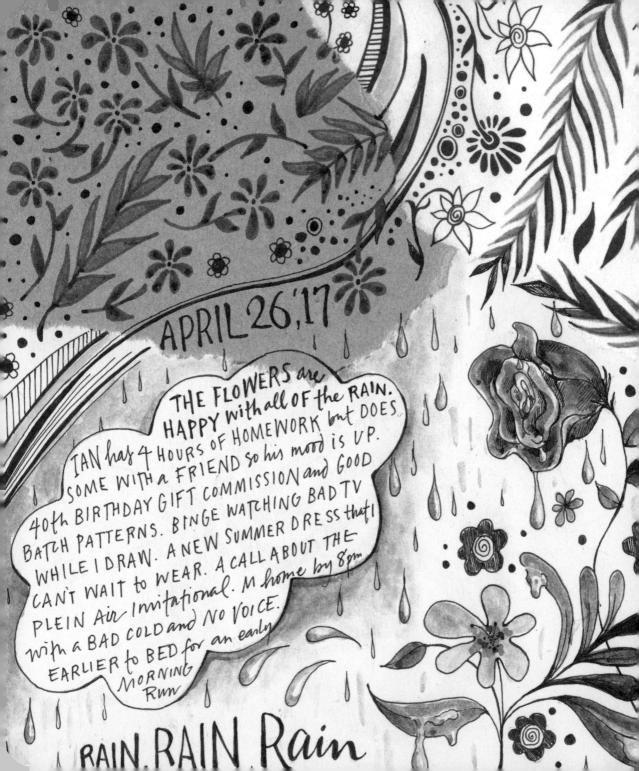

APRIL 26, '17

THE FLOWERS are HAPPY with all OF the RAIN. IAN has 4 HOURS OF HOMEWORK but DOES SOME WITH a FRIEND so his mood is UP. 40th BIRTHDAY GIFT COMMISSION and GOOD BATCH PATTERNS. BINGE WATCHING BAD TV WHILE I DRAW. A NEW SUMMER DRESS that I CAN'T WAIT to WEAR. A CALL ABOUT THE PLEIN Air Invitational. M home by 8pm with a BAD COLD and NO VOICE. EARLIER to BED for an early MORNING RUN

RAIN. RAIN. Rain

DAY #4: STOWE, VERMONT: third day at gym & spa while boys ski. The snow is still coming down when we wake up. Lunch solo at Flannel and I have a salad with a side of sweet potato fries. Dinner with Cresci's and a walk in town. We buy some maple syrup, of course, and another afternoon nap, prior, in the hotel room. ☆

a family of Snow Boots

DECEMBER 30th 2015

Nature

Whether you live in the city or country, nature is all around us, and it is an important source of inspiration. Basic shapes in nature, like leaves, petals, or clouds, can be drawn large or small, and these shapes can fill in empty areas on your page. You can spend some time on a walk collecting a few leaves of various shapes and copy them on your pages. From leaves on the path around your feet, to leaves high in the sky on a tree, adding elements of nature to your pages can be like a breath of fresh air after a day spent at a computer or commuting.

A DEAD LEAF ON LAFAYETTE

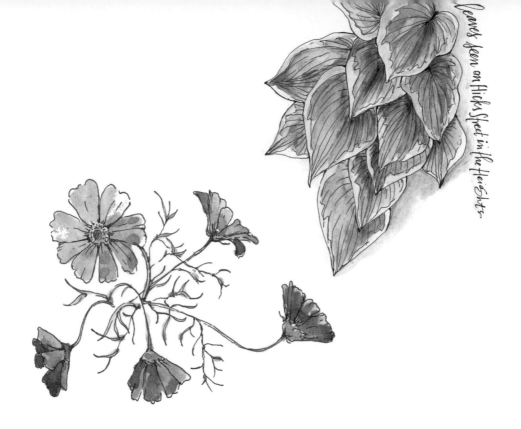

leaves seen on Hicks Street in the Heights

The colors in nature—sepias, greens, the vast array of bright colors found in flowers and produce—are also a great reference to feed your journal entries. Any colors you would like to highlight in your illustrations can be echoed in small arrangements of leaves or flowers. For example, let's say that you have illustrated a few items from the grocery store: your cereal box is mostly green and brown, and your new bottle of shampoo is bright pink. Green leaves and pink flowers can fill some of your empty space perfectly and can provide balance to the composition by repeating colors around the page.

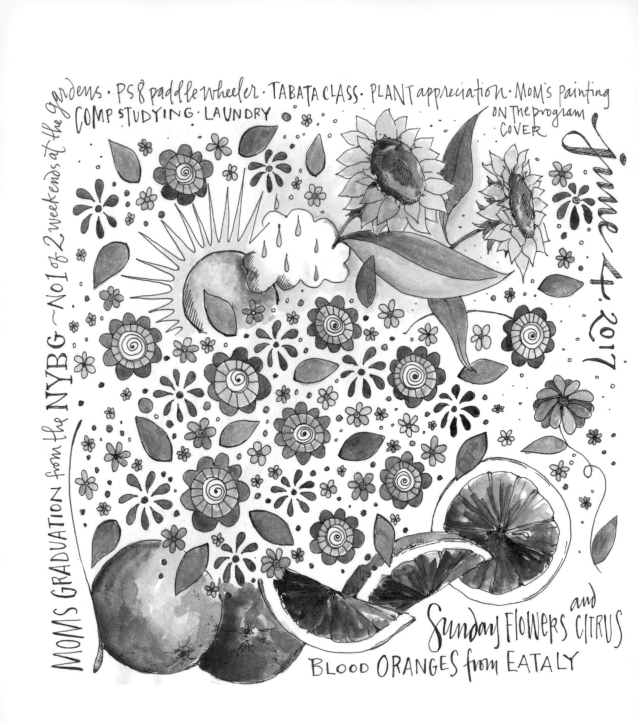

gardens · PS 8 paddle wheeler · TABATA CLASS · PLANT appreciation · MOM'S Painting
COMP STUDYING · LAUNDRY
ON The program COVER

June 4, 2017

MOM'S GRADUATION from the NYBG ~ NO 1 of 2 weekends at the gardens

Sunday FLOWERS and CITRUS
BLOOD ORANGES from EATALY

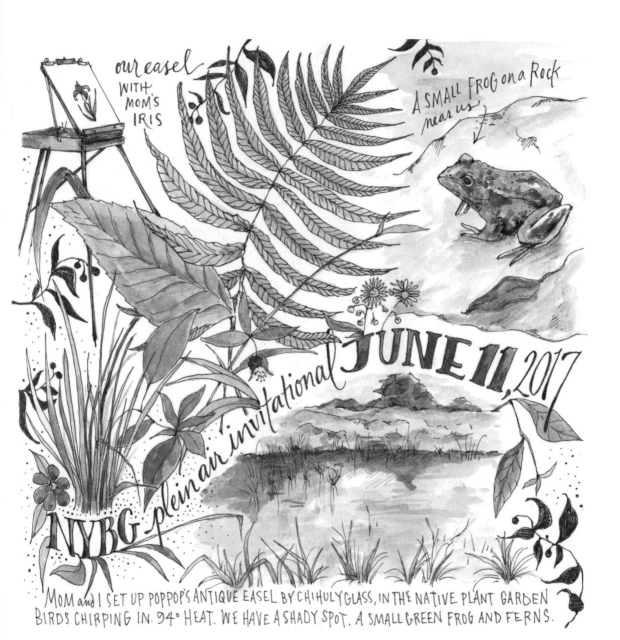

our easel
WITH
MOM'S
IRIS

A SMALL FROG on a Rock
near us

NYBG — plein air invitational JUNE 11, 2017

MOM and I SET UP POPPOP'S ANTIQUE EASEL BY CHIHULY GLASS, IN THE NATIVE PLANT GARDEN
BIRDS CHIRPING IN. 94° HEAT. WE HAVE A SHADY SPOT. A SMALL GREEN FROG AND FERNS.

the mail slot

Buildings and Architecture

When you capture your environment in your journal, in years to come, you'll be able to turn the pages and see how the streets, the stores, the homes appeared to you. With time, stores may close down, something else will open or a new facade will be added, the scenery and trees will change. I live in an urban setting, and the buildings and stores I walk by every day are filled with memories. I love drawing them and recording them for future reference and reflection. Architecture and the perspective involved in drawing it can be intimidating, but with practice you can capture places in a style that's your own. Perspective doesn't have to be perfect. Sometimes houses or buildings look great if one side is bigger than the other or the lines aren't straight. Just have fun experimenting.

You can also look on YouTube for perspective drawing tutorials or look at drawing books. You will learn about one-point, two-point, and three-point perspective (which

simply means that there are one, two, or three points on a horizon where all lines meet). Once you study the rules of perspective, there is often an "aha" moment. Knowing the rules and finding creative and successful ways to break them is what gives your journal and artwork a bit of you, your personality, and your artistic touch. And focusing on something specific like architecture or architectural details is a great place to experiment. I love quirky and unique drawings of windows, doors, rooftops, or a full row of houses; just like a caricature of a person, buildings can have so much personality.

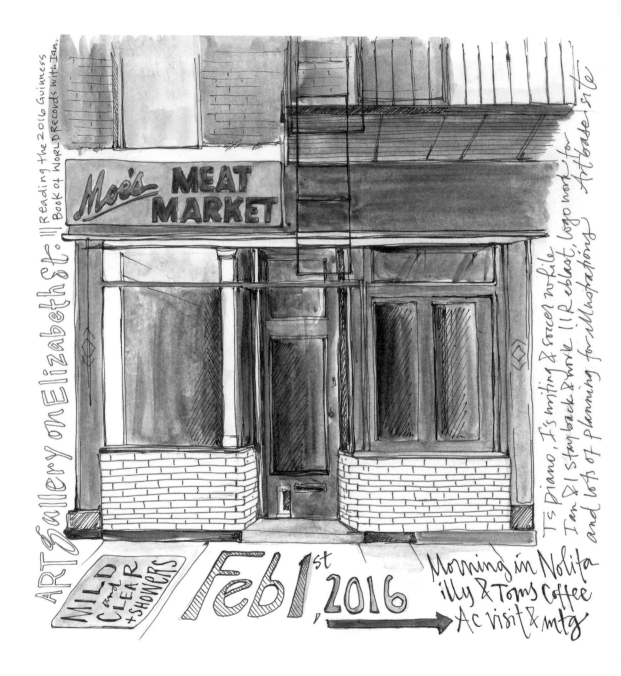

ART Gallery on Elizabeth St. !!! Reading the 2016 Guinness Book of World Records with Ian.

Moe's MEAT MARKET

MILD and CLEAR + SHOWERS

Feb 1st, 2016

Morning in Nolita
illy & Toms Coffee
Ac visit & mtg

T's piano, I's writing & soccer while Ian & I stay back & work !! Reboot, logo work for and lots of planning for illustrations, Artbase site

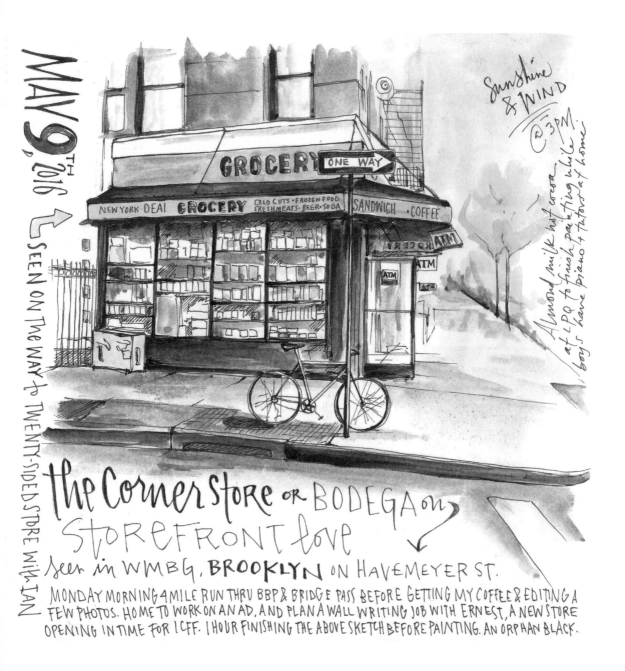

MAY 9TH 2016 ← SEEN ON THE WAY to TWENTY-SIDED STORE WITH IAN

GROCERY
ONE WAY
NEW YORK DELI GROCERY COLD CUTS · FROZEN FOOD FRESH MEATS · BEER · SODA SANDWICH · COFFEE
ATM
ATM

Sunshine & WIND @ 3PM

Almond milk hot cocoa at LPQ to finish painting while boys have piano + tutor at home

The Corner Store OR BODEGA on STOREFRONT love
Seen in WMBG, BROOKLYN ON HAVEMEYER ST.

MONDAY MORNING 4 MILE RUN THRU BBP & BRIDGE PASS BEFORE GETTING MY COFFEE & EDITING A FEW PHOTOS. HOME TO WORK ON AN AD, AND PLAN A WALL WRITING JOB WITH ERNEST, A NEW STORE OPENING IN TIME FOR LCFF. I HOUR FINISHING THE ABOVE SKETCH BEFORE PAINTING. AN ORPHAN BLACK.

A Busy Day

Sometimes, on really busy days, I carry around my sketchbook, jot down notes, and begin small drawings while on the subway or waiting in line at the grocery store (the lines can be really long at Trader Joe's!). I find that small breaks with my book are really refreshing when I am running around, even if I just have five minutes.

It is fun for me to capture the life of a working mom living in New York City by writing down all of the things I manage to do in one day. You can use arrows to show the stream of events or work in a circle to illustrate how the day goes around and around, until you settle in the middle of the page at bedtime. These pages can also be worked on over time. You can jot a few things down over a week and spend about fifteen minutes a day just drawing little significant pieces until you run out of space. One page can even flow right to the next. Jotting down all of the small things that I manage to squeeze into a set period of time gives me a great sense of accomplishment.

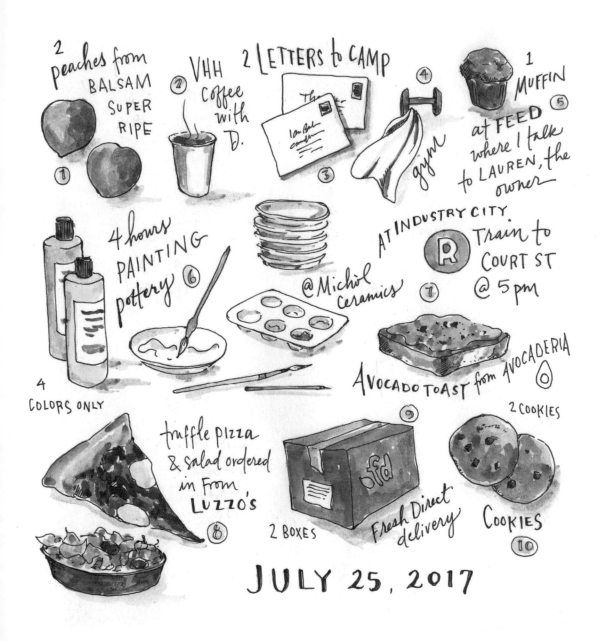

2 peaches from BALSAM SUPER RIPE ①

② VHH coffee with D.

2 LETTERS to CAMP ③

④ gym

1 MUFFIN at FEED where I talk to LAUREN, the owner ⑤

4 hours PAINTING pottery ⑥

4 COLORS ONLY

AT INDUSTRY CITY. @Michol Ceramics ⑦

Ⓡ Train to COURT ST @ 5 pm

Avocado Toast from AVOCADERIA ⓪

truffle pizza & salad ordered in from LUZZO's ⑧

2 BOXES

Fresh Direct delivery ⑨

2 COOKIES Cookies ⑩

JULY 25, 2017

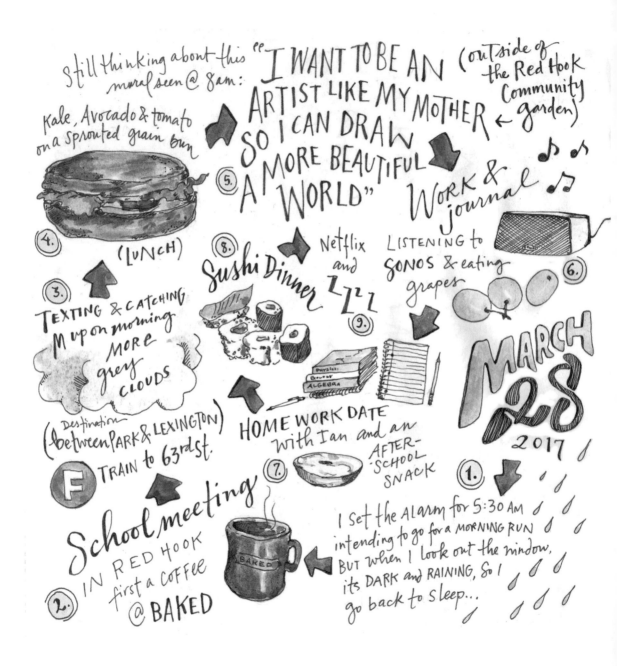

still thinking about this mural seen @ 8am:

"I WANT TO BE AN ARTIST LIKE MY MOTHER SO I CAN DRAW A MORE BEAUTIFUL WORLD"

(outside of the Red Hook community garden)

5.

Kale, Avocado & tomato on a sprouted grain bun

4. (LUNCH)

3. TEXTING & CATCHING UP on morning

MORE grey CLOUDS

Work & journal

8. Sushi Dinner

Netflix and Z Z Z

9.

LISTENING to SONOS & eating grapes

6.

MARCH 28 2017

(Destination between PARK & LEXINGTON) F TRAIN to 63rd St.

HOME WORK DATE With Ian and an AFTER-SCHOOL SNACK

7.

School meeting IN RED HOOK first a coffee @ BAKED

2.

BAKED

1. I set the ALARM for 5:30 AM intending to go for a MORNING RUN but when I look out the window, its DARK and RAINING, so I go back to sleep...

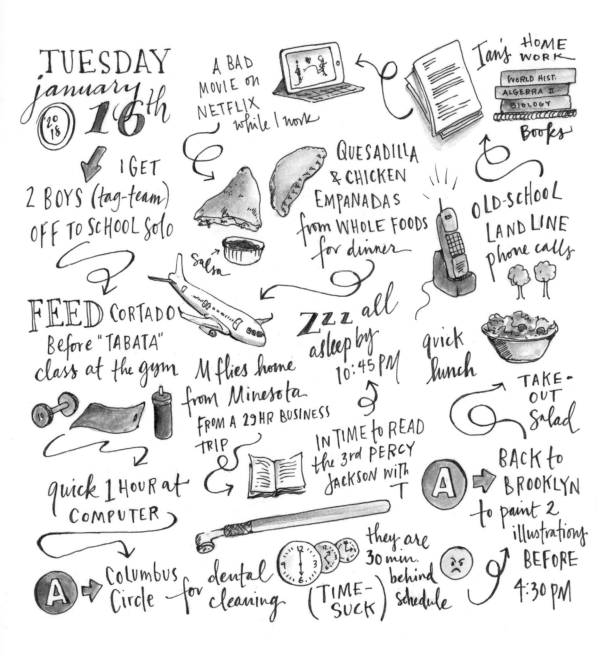

TUESDAY january 16th '20 18

A BAD MOVIE on NETFLIX while I work

Ian's HOME WORK
WORLD HIST.
ALGEBRA II
BIOLOGY
Books

I GET 2 BOYS (tag-team) OFF TO SCHOOL solo

QUESADILLA & CHICKEN EMPANADAS from WHOLE FOODS for dinner

salsa

OLD-SCHOOL LAND LINE phone calls

FEED CORTADO Before "TABATA" class at the gym

M flies home from Minesota FROM A 29 HR BUSINESS TRIP

ZZZ all asleep by 10:45 PM

quick lunch

TAKE-OUT Salad

quick 1 HOUR at COMPUTER

IN TIME to READ the 3rd PERCY JACKSON with T

A BACK to BROOKLYN to paint 2 illustrations BEFORE 4:30 PM

A Columbus Circle for dental cleaning

they are 30 min. behind schedule (TIME-SUCK)

Quotes and Special Words

It's always in the back of my mind that my journals will be passed on to my kids one day (and hopefully their kids will look at them as well). Because they are watching me through this journey, I create messages especially for them. You can remember valuable lessons, whether spiritual or motivational; commemorate a person or a current event; or mark a feeling by finding a good quote or, better yet, using your own words. Since I don't think of myself as a writer, I search for other people's words in books and online that I personally find meaningful.

Many people find it motivating to write verses from the Bible. Others are avid poetry readers. Others write lines from films. I have found quotes on the subway (the New York City Metro's program puts Poetry in Motion posters with poems on trains) and in street art, but most often I find them online or through friends on social media. When

Write it on your heart that EVERY DAY IS THE BEST day in the year — RALPH WALDO EMERSON

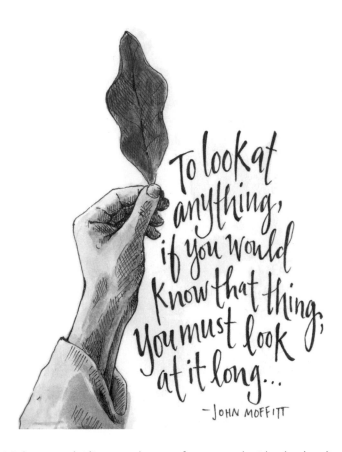

To look at anything, if you would know that thing, you must look at it long...

—John Moffitt

Muhammad Ali passed away, for example, I looked online for things he said and chose a few quotations to commemorate him. You can also highlight a single word: "happiness," for example, if you've experienced a wonderful day; "sleep," if you are craving a good night's sleep; "downpour," if you got soaked on the way home. Highlighting quotes or words is also a great way to play with lettering. Pull out those brush pens or try painting the words with watercolor.

WHEN you get INTO A TIGHT place, and EVERY-THING GOES against YOU till it SEEMS AS IF YOU COULDNT HOLD ON A minute LONGER, NEVER Give UP THEN, for THAT'S JUST the PLACE and TIME that the TIDE will TURN

November 23 · 2016

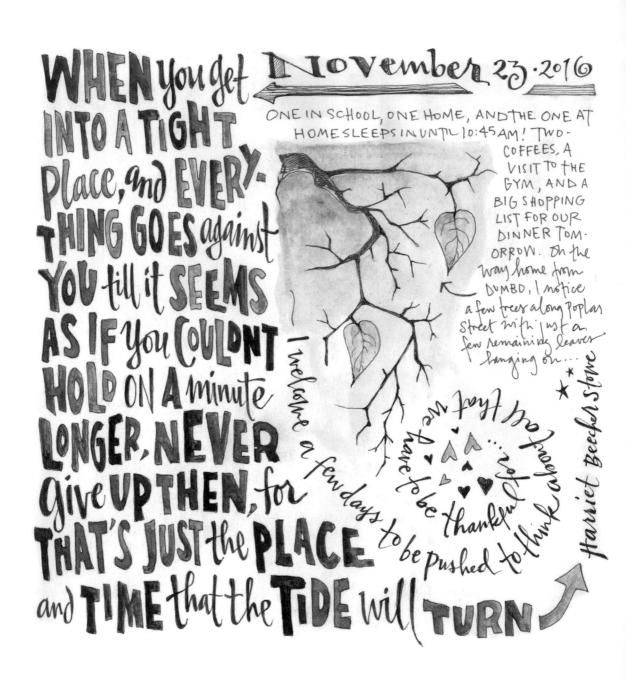

ONE IN SCHOOL, ONE HOME, AND THE ONE AT HOME SLEEPS IN UNTIL 10:45 AM! TWO COFFEES, A VISIT TO THE GYM, AND A BIG SHOPPING LIST FOR OUR DINNER TOMORROW. On the way home from DUMBO, I notice a few trees along Poplar Street with just a few remaining leaves hanging on...

I welcome a few days to be pushed to think about all that we have to be thankful for... Me thought

Harriet Beecher Stowe

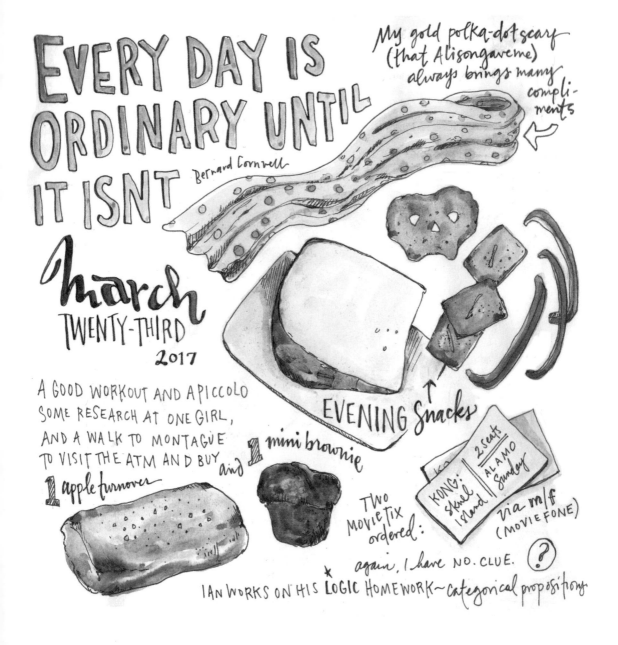

EVERY DAY IS ORDINARY UNTIL IT ISNT
Bernard Cornwell

My gold polka-dot scarf (that Alison gave me) always brings many compliments

march
TWENTY-THIRD
2017

A GOOD WORKOUT AND A PICCOLO SOME RESEARCH AT ONE GIRL, AND A WALK TO MONTAGUE TO VISIT THE ATM AND BUY

1 apple turnover

and 1 mini brownie

EVENING snacks

TWO MOVIE TIX ordered:

2 seats
KONG: skull island
ALAMO Sunday

via m/f
(MOVIEFONE)

again, I have NO CLUE. (?)

★ IAN WORKS ON HIS LOGIC HOMEWORK ~ categorical propositions

Everyday Objects

Clothing, grocery store or drug store items, makeup, keys, jewelry, sports equipment—all of the little things that we take for granted and use daily are really fun to draw. If we think of a drawing practice as, in part, bringing the mundane to life, then the simple act of drawing your toothbrush can in itself be worthwhile. For instance, I put on the same lip gloss about five times a day, and so any day I decide to include it in my journal is okay. It's a bonus that I can look back at that drawing of my lip gloss years from now and remember the packaging and the smell and feel of using it. You can also try including the same item over multiple days from different angles. Think of it as practice. Illustrating something from varying points of view is a great exercise in drawing a three-dimensional object. Maybe that square that you put under the date can hold a different everyday object. Try emptying your handbag, workbag, or backpack one day and draw a handful of the items that fall out.

A WARM
RUNNING
BATH

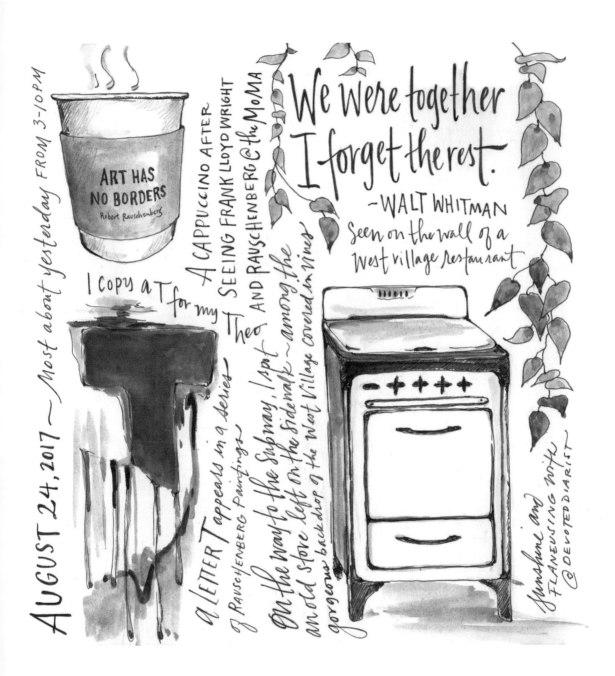

AUGUST 24, 2017 ~ Most about yesterday FROM 3-10PM

ART HAS NO BORDERS
Robert Rauschenberg

I COPY a T for my Theo

A CAPPUCCINO AFTER SEEING FRANK LLOYD WRIGHT AND RAUSCHENBERG @ the MoMA

A LETTER T appears in a series of Rauschenberg Paintings

On the way to the Subway, I spot an old stove left on the sidewalk ~ among the gorgeous backdrop of the West Village covered in vines

We were together I forget the rest.
–WALT WHITMAN
Seen on the wall of a West Village restaurant

Sunshine and FLANEUSING with @DEVOTEDDIARIST

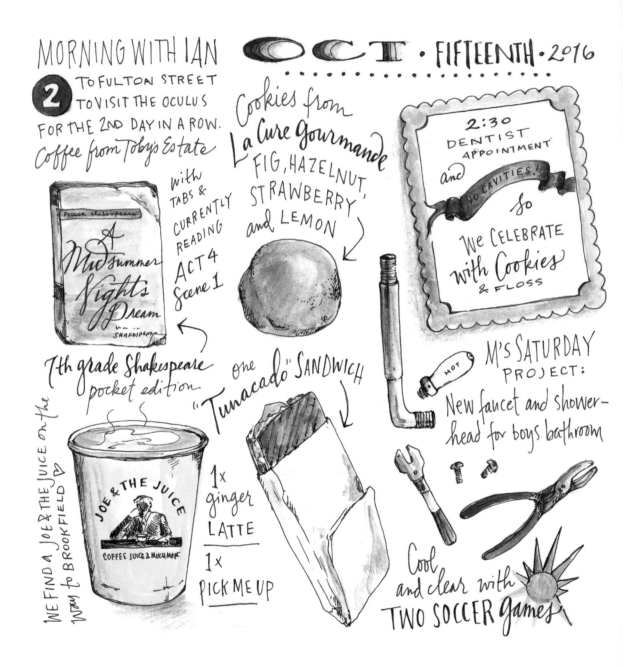

MORNING WITH IAN · OCT · FIFTEENTH · 2016

(2) TO FULTON STREET TO VISIT THE OCULUS FOR THE 2ND DAY IN A ROW.
Coffee from Toby's Estate

with TABS & CURRENTLY READING ACT 4 Scene 1

Cookies from La Cure Gourmande FIG, HAZELNUT, STRAWBERRY and LEMON

A Midsummer Nights Dream

7th grade Shakespeare pocket edition

We find a Joe & the Juice on the way to Brookfield ♡

JOE & THE JUICE
COFFEE JUICE & MUCH MORE

1x ginger LATTE
1x PICK ME UP

one "Tunacado" SANDWICH

2:30 DENTIST APPOINTMENT
and NO CAVITIES!
So We CELEBRATE with Cookies & FLOSS

HOT

M'S SATURDAY PROJECT:
New faucet and shower-head for boys bathroom

Cool and clear with TWO SOCCER games.

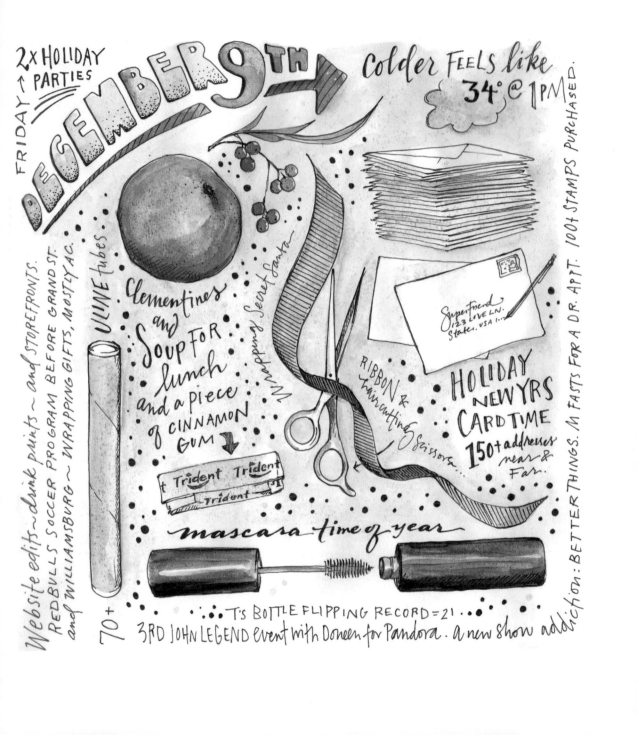

FRIDAY → 2x HOLIDAY PARTIES

DECEMBER 9TH

Colder feels like 34° @ 1PM

100+ STAMPS PURCHASED.

Website edits ~ drink prints ~ and STOREFRONTS.
REDBULLS SOCCER PROGRAM BEFORE GRAND ST.
and WILLIAMSBURG ~ WRAPPING GIFTS, MOSTLY A.C.

ULINE tubes

Clementines
and
Soup for
lunch
and a piece
of CINNAMON
GUM

Wrapping Secret Santa

Trident Trident
Trident

RIBBON &
hair cutting
Scissors...

Superfriend
123 LOVE LN.
States, USA 1...

HOLIDAY
NEW YRS
CARD TIME
150+ addresses
near &
Far.

BETTER THINGS. M FASTS FOR A DR. APPT.

mascara time of year

70+

T's BOTTLE FLIPPING RECORD = 21

3RD JOHN LEGEND event with Doreen for Pandora. A new show addiction:

Food and Drinks

How can a daily journal exist without some sort of documentation of food? Food and drinks are the foundation of our health, our social interactions, and our travel. My husband likes to read restaurant reviews to find the best places to eat when we travel. I am happy with a baguette and cheese, eaten on a bench in the park. My younger son is addicted to anything sweet and has a finicky palate, while my older son is adventurous and will try anything. What we choose to eat, how it tastes, and what it looks like can help shape any page.

I start each day with a coffee. Just one, and it has to be special. Since I work from home, I like to spend part of each day in a local café or park. Sipping my coffee as my eyes focus on a new day, the energy of people around me sparks my creativity, and therefore almost all of my journal pages. I truly savor that cup of coffee I order, and I consider the money spent a small donation to the city in exchange for all of its inspiration. I even created a special project based on my daily morning drink: I illustrated a warm drink each day for thirty days. As the project progressed, my mugs and take-away cups improved. I was able to draw the round cylinders in perspective, with more accurate curves, and the lettering or logo wrapping around a little better each time I tried.

The possibilities of incorporating food are endless and help take you back to special moments as you flip through your sketch journal. Coffee, tea, smoothies, salads, fruit (either cut or whole) cookies, and candy—these foods all fuel my pages. The illustrations bring me back to the taste of the foods and that brings me joy. Remembering a celebratory meal or a conversation over lunch can be as simple as illustrating one ingredient or a glass of wine surrounded by words to describe the occasion. Small food items are perfect for filling spaces around your larger illustrations or areas of interest. How perfect is a handful of M&M's, or some pistachio shells or grains of rice, falling down your journal page to fill empty spaces.

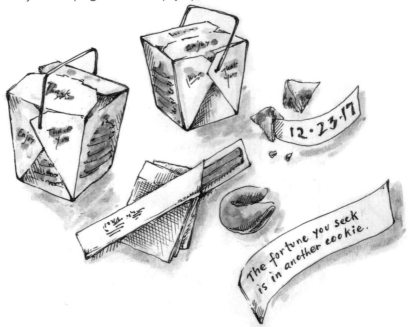

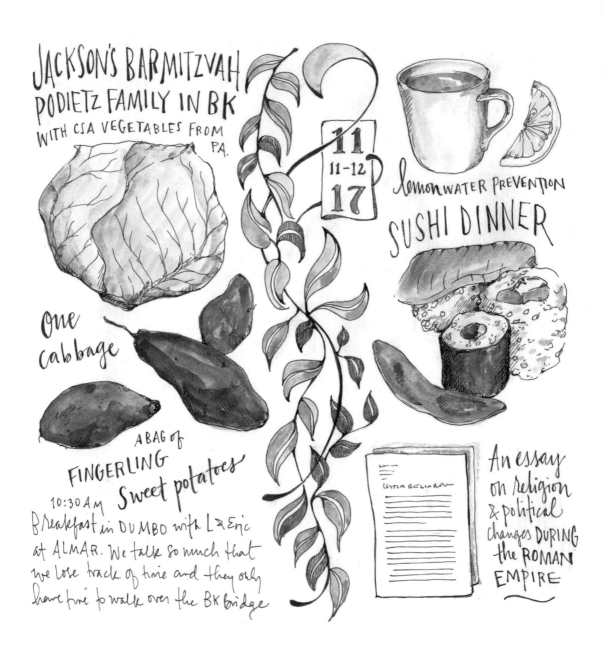

JACKSON'S BAR MITZVAH
PODIETZ FAMILY IN BK
WITH CSA VEGETABLES FROM
P.A.

11
11-12
17

lemon water prevention

SUSHI DINNER

One
cabbage

A BAG OF
FINGERLING
Sweet potatoes

10:30 AM
Breakfast in DUMBO with L & Eric
at ALMAR. We talk so much that
we lose track of time and they only
have time to walk over the BK bridge

An essay
on religion
& political
changes DURING
the ROMAN
EMPIRE

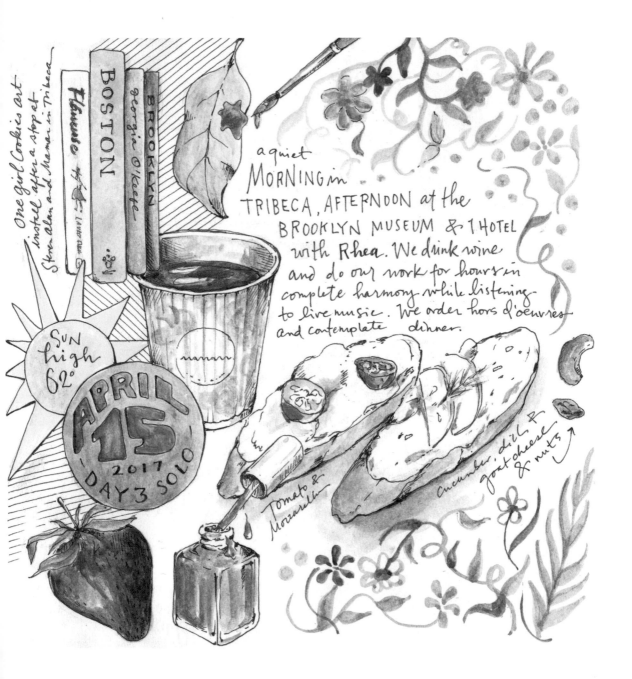

One girl cookie art in hotel after a stop at Steven Alan and Maman in Tribeca

Flânuese

BOSTON

Georgia O'Keeffe

BROOKLYN

Sun high 62°

APRIL 15 2017 DAY 3 SOLO

a quiet MORNING in TRIBECA, AFTERNOON at the BROOKLYN MUSEUM & 1 HOTEL with Rhea. We drink wine and do our work for hours in complete harmony while listening to live music. We order hors d'oeuvres and contemplate dinner.

Tomato & Mozzarella

cucumber, dill & goat cheese & nuts

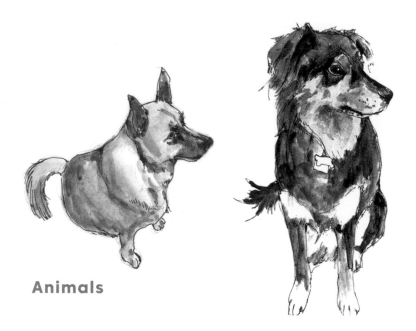

Animals

Animals often appear on my journal pages, because I love all animals, and also love to draw them. Their faces are easier and less intimidating to me than people's, and they just make me smile. I find that the relationship I have with the local dogs lends so much to the story of my days. When I flip through my journals, the pages that include animals always bring me right back to that moment. If you own a pet, practice drawing him or her in various positions. A sleeping pet is a perfect thing to draw from life, since you can count on a certain amount of stillness. If you are worried your cat or dog will wake up, or if you are running out of time and haven't finished, then snap a photo with your phone so that you can go back to finish the drawing later.

Drawing animals presents opportunities to be so expressive: You can paint their fur with textures or random colors or even create their bodies out of torn paper. I happen to illustrate animals in a very realistic way, but many artists will transform a dog, for example, into a colorful character with exaggerated features. Have fun experimenting with animal forms. Or have them create a dialog on the page. Animals can communicate your moods and feelings with thought bubbles. A dog anxiously waiting outside a café can have that look on its face like, "Hey you, hi, can you tell my human to come out and untie me?" or a cat sitting in a window completely unfazed by your attention could be thinking, "Yeah, I know you're there, but I'm not going to look at you." Animals can be friendly vehicles for you to express ideas, or they can be an unexpected visual to capture a moment in time.

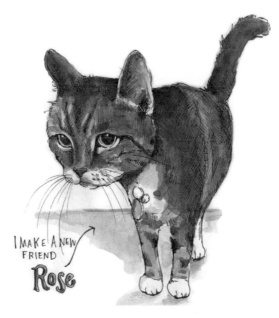

I MAKE A NEW FRIEND

Rose

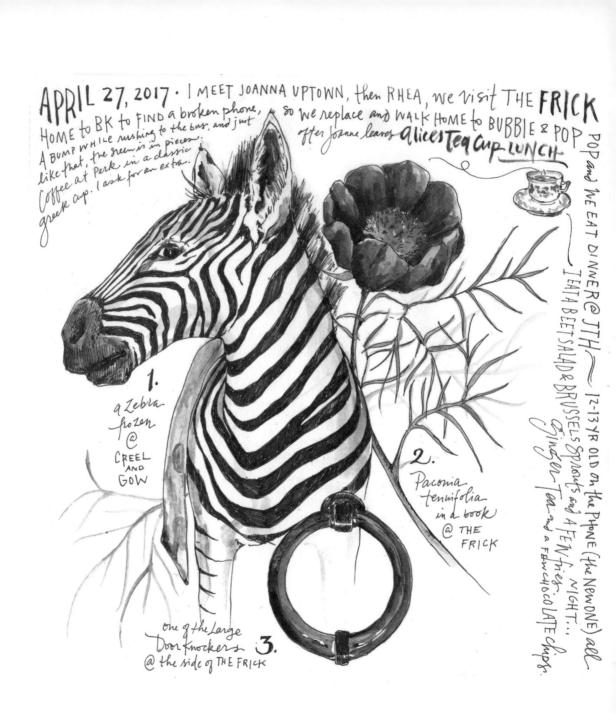

APRIL 27, 2017 • I MEET JOANNA UPTOWN, then RHEA, we visit THE **FRICK**

HOME to BK to FIND a broken phone, so we replace and WALK HOME to BUBBLE & POP
A BUMP WHILE rushing to the bus, and just after Joanne leaves *Alices Tea Cup* LUNCH
like that, the screen is in pieces.
Coffee at Perk in a classic
greek cup. I ask for an extra.

POP and WE EAT DINNER @ JTH — 12-13 YR OLD on the PHONE (the NEW ONE) all
NIGHT... I HAT A BEET SALAD & BRUSSELS Sprouts and A FEW fries,
Ginger Tea and a Few CHOCOLATE chips.

1.
a Zebra
frozen
@
CREEL
AND
GOW

2.
Paeonia
tenuifolia
in a book
@ THE
FRICK

one of the Large
Door Knockers **3.**
@ the side of THE FRICK

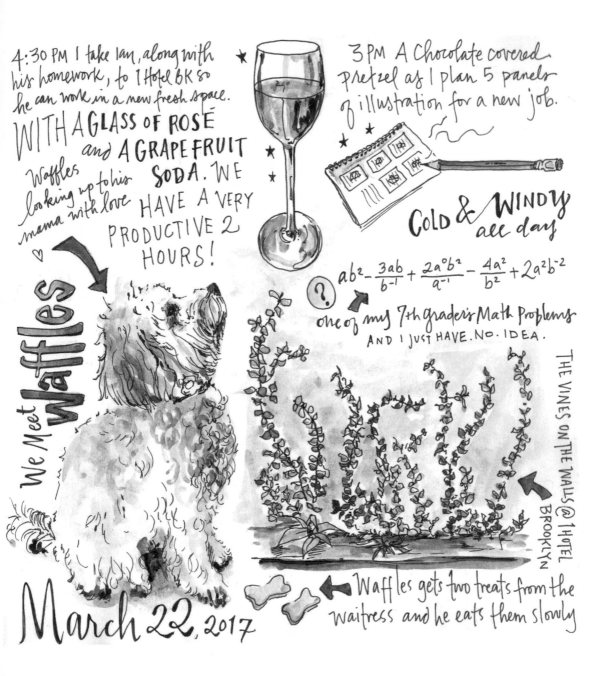

4:30 PM I take Ian, along with his homework, to 1 Hotel BK so he can work in a new fresh space.
WITH A **GLASS OF ROSÉ** and **A GRAPEFRUIT SODA. WE HAVE A VERY PRODUCTIVE 2 HOURS!**

Waffles looking up to his mama with love ♡

3 PM A chocolate covered pretzel as I plan 5 panels of illustration for a new job.

COLD & WINDY all day

$$ab^2 - \frac{3ab}{b^{-1}} + \frac{2a^0b^2}{a^{-1}} - \frac{4a^2}{b^2} + 2a^2b^{-2}$$

one of my 7th grader's Math Problems AND I JUST HAVE. NO. IDEA.

We Meet **Waffles**

THE VINES ON THE WALLS @ 1 HOTEL BROOKLYN

March 22, 2017

Waffles gets two treats from the waitress and he eats them slowly

People

Drawing people is its own skill and to get comfortable with it can take years of practice. Figure drawing is the most classic art school course, and it is an extremely valuable experience if you have time and class availability. There are also hundreds of figure drawing books, online courses, and YouTube videos on the subject. What it all boils down to is a little similar to what I wrote about in the architecture section. The human figure and face can be broken down into parts and can be drawn in perspective, just like a building. It is helpful to know the basic proportions of the body when drawing people. For example, I know that when a human spreads their arms out wide to the sides, the distance from left fingertips to right fingertips correlates to the person's height. I also know that the eyes fall in the center of the head, not closer to the top, as many people think. And the width of a person's nose is equal to the width of each eye. It is useful to have a basic understanding of anatomy and to practice from life to confidently illustrate people. And once the rules are understood, it is easier to create carefree characters for your figures. Picasso learned to draw people accurately before creating his Cubist style. I often think of *New Yorker* cartoonists and how easily they draw figures in any position, always in proportion, and I am so envious of this skill. I dream of drawing figures as easily as I draw a bowl of fruit.

I have a large portfolio from my art school years filled with figure drawings. I cherish them, and I often think about taking another course. Illustrating people doesn't come easily to me, but I have forced myself to practice through the years, and it is getting easier. Sometimes there is no better way to illustrate a day than to include people, so it is something I will continue to challenge myself to do. You can draw people by taking a snapshot and working from the photo or by illustrating someone who is perfectly still. Or you can practice quick gesture drawing, which is an extremely useful practice as you learn about human

1 MATCHA latte and A MAN READING the PAPER @ LUDLOW COFFEE SUPPLY.

proportions and how the shapes of the body relate to one another. These are typically very quick sketches, drawn in just one to five minutes, depending on your style and speed. Or you can create contour drawings that explore just the outline of shapes. These are often done in one continuous line, without looking at the paper. There are many useful exercises that encourage you to break a figure down to its most basic shapes, allowing you to build upon the sketches as you grow and develop your style and skills.

If you draw people in still moments, you have more time to make mistakes and to work out the figure in pencil. I like to draw people from behind or looking down. I am not sure why. Maybe because I can avoid making the face exact. When you draw an animal, and the eye is a touch off or the nose a bit long, it's not as apparent. But with faces, even the slightest shift in a feature makes it looks all wrong. So for me, it feels safer to capture people walking away, looking down, turned to the side. It may also be that I simply don't like posed shots of people. I am not one to tell a group to stand in a row and smile. I prefer to catch people in candid moments. I am the one at the party taking secret photographs or raising my camera above people's heads. I get dozens of bad photographs this way, but it's the one great capture that makes it worthwhile. These are the moments I also choose to draw. A man reading in a café, a woman on a park bench, or a figure walking down a path are some examples of people you will see in my journal pages.

Attention is the rarest and purest form of Generosity.

— SIMONE WEIL —

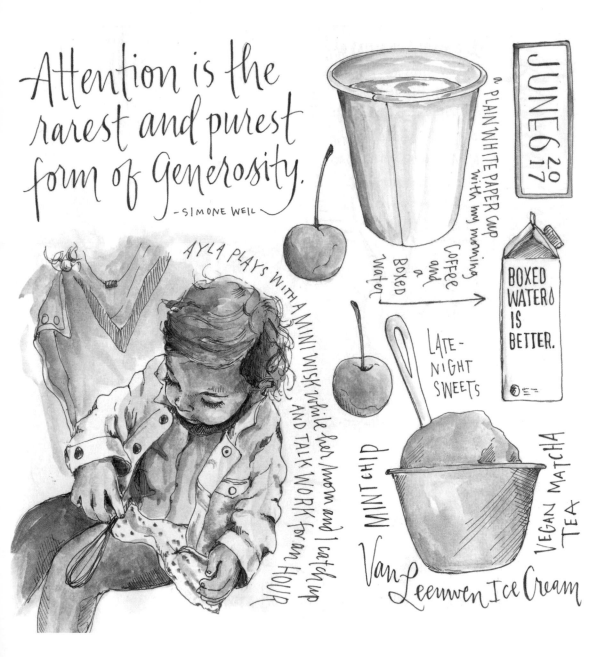

JUNE 6 2017

a PLAIN WHITE PAPER CUP with my morning Coffee and a Boxed Water

BOXED WATER IS BETTER.

AYLA PLAYS WITH A MINI WISK while her Mom and I catch up AND TALK WORK for an HOUR

LATE-NIGHT SWEETS

MINT CHIP

VEGAN MATCHA TEA

Van Leeuwen Ice Cream

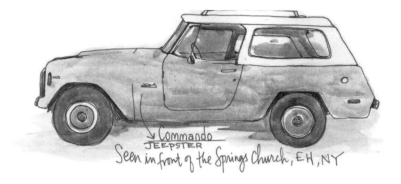

↓Commando
JEEPSTER
Seen in front of the Springs Church, EH, NY

CONCLUSION

Life takes so many interesting and unexpected turns. Drawing, painting, and writing about your days can provide you with a sense of peace and a deeper understanding of your thoughts and dreams. I know that drawing can be humbling and sometimes frustrating when you first begin. But if you practice a little bit each day, you will see gratifying improvement. It is important to remember that you can approach your sketch journal from so many creative angles, expressing and releasing your memories and creativity simultaneously. I realize that keeping an illustrated visual sketch journal is not for everyone, but I am quite certain that if I sat down with even my most non-drawing friends, I would be able to convince them that there is a way for anyone to have a similar practice. You don't have to be able to draw the same way that I do; you don't even have to draw at all. Write and splash some color on your pages, as you keep track

of the places you go and the things you do. Make thought bubbles, rub some color around a particular memory you write about, glue down a piece of your Playbill after you go to the theater, and then make the prominent color for that page bright yellow. Make little stick figures engage in a conversation on top of a fun patterned tissue paper found in your shopping bag. If you feel overwhelmed by the possibilities, then my work is done. Most importantly, have fun and enjoy the creative freedom of experimenting as you draw your day!

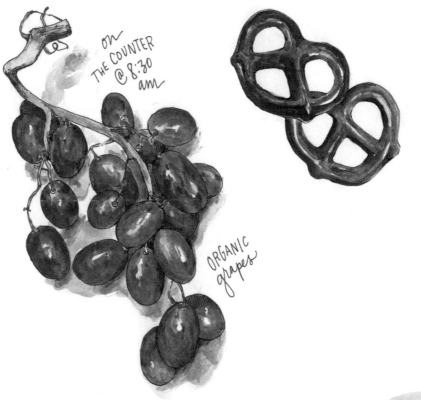

ON THE COUNTER @ 8:30 am

ORGANIC grapes

RESOURCES

Many of the items in the "Tools and Materials" section (page 33) can be ordered online from Dick Blick (www.dickblick.com) or Amazon or purchased at your local art supply store. The following items are readily available and can be researched and purchased through the manufacturer websites:

Caran d'Ache
store.carandache.com/us/en
Soft water-soluble Supracolor colored pencils and Neocolor II water-soluble pastels.

Copic
copic.jp/en
Multiliners, nibs, ink cartridges, and original Copic markers.

CW Pencil Enterprise
www.cwpencils.com
Craft Design Technology plastic eraser, the Seed Radar eraser, and the Möbius & Rupert bullet sharpener, and just about the best resource for pencils, including Caran d'Ache Swiss Wood pencil, and Palomino Blackwing.

Faber-Castell
www.fabercastell.com
Polychromes, colored pencils and drawing pencils.

Fabriano
www.fabrianoboutique.com
Roll-style case for colored pencils.

Handbook Paper Co.
www.globalartmaterials.com
Travelogue Art Journals.

Moleskine
us.moleskine.com
Sketch Albums in various sizes, as well as Moleskine Watercolor Notebooks.

MT Tape

mt-tape.us
A great array of washi tapes.

Muji

www.muji.com
Glue sticks, pens and markers, and portable scissors.

Pentel Arts

www.pentel.com/pentel-arts
Water-based color brush pens and sets.

Prismacolor

www.prismacolor.com
High-quality Premier colored pencils.

Sakura of America

sakuraofamerica.com
Koi Pocket Field Sketch Box watercolor sets and Pigma Micron fine line pens.

Stabilo

www.stabilo.com
High quality pens and pencils.

Staedtler

www.staedtler.us/en
Mars plastic erasers, markers, and pencils.

Tombow

tombowusa.com
Dual brush pens in a variety of colors, including black.

ACKNOWLEDGEMENTS

This book would never have happened without the love and support of my family and friends. I cannot even begin to list everyone, but there are some I must call out and recognize in a bit more detail.

Thank you to my parents, Deborah and Alan Dion, who encouraged me to follow my dreams from day one and told me I didn't have to be an artist like the rest of the women in my family. I thought long and hard about doing something else, but once I decided to begin a journey on the creative path, I always knew you were watching with pure pride and love.

Thank you to my beautiful and ever-inspiring sister, Joanna Brown. Since we were little girls, I could watch you draw for hours, eyes widening with each stroke you took, in complete awe. I'll probably never be able to draw as well as you do, but I can only keep trying. Thank you for encouraging me, for your patience, and for not getting too annoyed as I continue to look over your shoulder.

Thank you to my agent Laura Lee Mattingly, who came to me with an idea and was an instant friend, and without whom this book would never have been.

Thank you to the entire team at Ten Speed Press: Ashley Pierce, Lisa Ferkel for your gorgeous design skills,

Dan Myers for the production work, and Natalie Mulford and Eleanor Thacher for getting the word out about the book. A special shout-out to the incredibly talented Kaitlin Ketchum. Kaitlin, you guided me through a completely unknown process, made it fun, and helped me become a writer.

Thank you to my two boys, my two muses, Ian and Theo, who are my biggest cheerleaders. You are loved beyond measure. Thank you for keeping me young.

Last but not least, thank you to my very best friend and guiding light, Malcolm Baker. Your belief in me got this all started. Thank you for loving me and letting me love you back.

ABOUT THE AUTHOR

Samantha Dion Baker is originally from Philadelphia, where she grew up in a family of artists. She graduated from The Cooper Union in New York City and spent over twenty years working as a graphic designer. Now a full-time illustrator and artist, her favorite thing to do is wander the city streets and travel with her family, drawing all of the things she does, eats, and sees in the pages of her sketch journal. She lives and works in Brooklyn with her husband and two sons.

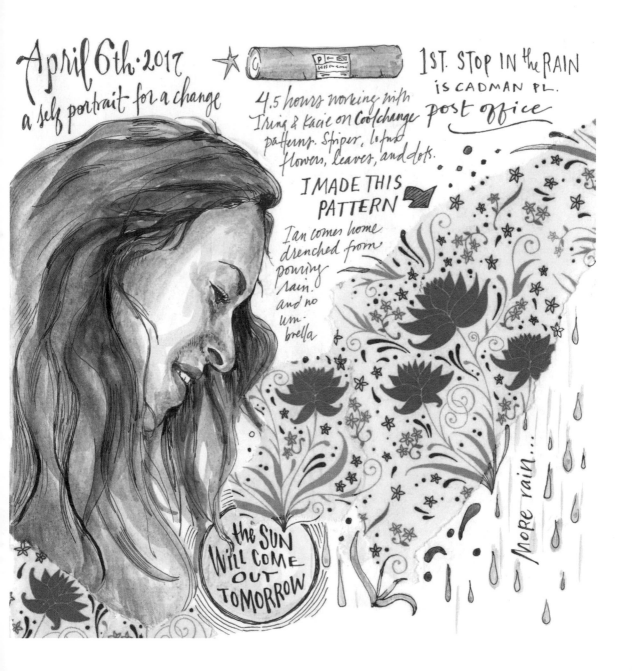

April 6th·2017
a self portrait for a change

4.5 hours working with
Irina & Kacie on Coolchange
patterns. Stripes, lotus
flowers, leaves, and dots.

1ST. STOP IN the RAIN
IS CADMAN PL.
post office

I MADE THIS
PATTERN

Ian comes home
drenched from
pouring
rain.
and no
um-
brella

the SUN
WILL COME
OUT
TOMORROW

MoRe rain....

All rights reserved.
Published in the United States by Watson-Guptill Publications, an imprint of the
Crown Publishing Group, a division of Penguin Random House LLC, New York.
www.crownpublishing.com
www.watsonguptill.com

WATSON-GUPTILL and the HORSE HEAD colophon are registered trademarks
of Penguin Random House LLC.

Some illustrations have been previously published.

Library of Congress Cataloging-in-Publication Data
Names: Baker, Samantha Dion, author.
Title: Draw your day : an inspiring guide to keeping a sketch journal
 by Samantha Dion Baker.
Description: First edition. | California : Watson-Guptill, 2018.
Identifiers: LCCN 2017052542 (print) | LCCN 2017053708 (ebook) |
(trade pbk. : alk. paper)
Subjects: LCSH: Drawing—Themes, motives. | Diaries—Authorship.
Classification: LCC NC715 (ebook) | LCC NC715 .B35 2018 (print) | DDC
 741—dc23
LC record available at https://lccn.loc.gov/2017052542

Trade Paperback ISBN: 978-0-399-58129-8
eBook ISBN: 978-0-399-58130-4

Printed in China

Design by Lisa Ferkel

10 9 8 7